PEGASUS
Library

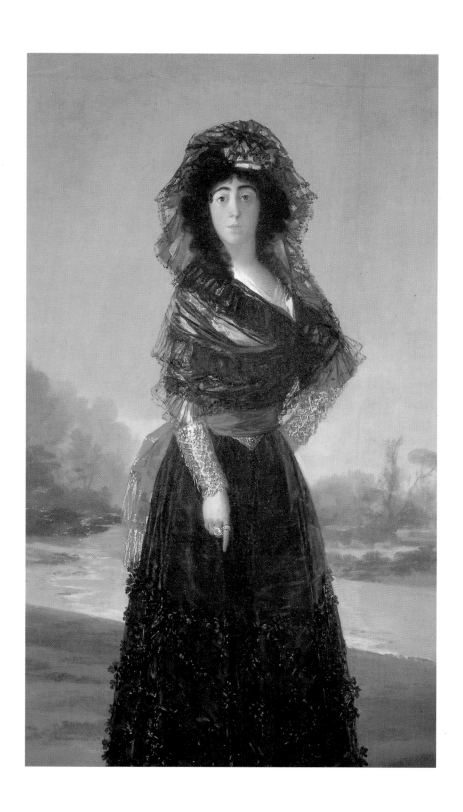

Susann Waldmann

Goya and the
Duchess of Alba

Prestel

Munich · London · New York

© Prestel-Verlag, Munich · London · New York, 1998

Photo credits: page 107

Front cover: *The Naked Maja* (*La maja desnuda*), ca. 1798–1800, detail of illus. on pages 58–59
Spine: *Young Woman Arranging Her Hair*, 1796–97, detail of illus. on page 42
Frontispiece: *Portrait of the Duchess of Alba in Black*, 1797, detail of illus. on page 48

Translated from the German by John Gabriel
Copyedited by Michele Schons

Prestel-Verlag
Mandlstrasse 26 · D-80802 Munich, Germany
Tel. (+49-89) 381709-0; Fax (+49-89) 381709-35
and 16 West 22nd Street, New York, NY 10010, USA
Tel. (212) 627-8199; Fax (212) 627-9866

Prestel books are available worldwide.
Please contact your nearest bookseller or write to either
of the above addresses for information concerning
your local distributor.

Designed by Daniela Petrini
Lithography by Repro Ludwig, Zell am See
Printed by Passavia Druckservice GmbH, Passau
Bound by MIB Conzella, Pfarrkirchen

Printed in Germany on acid-free paper

ISBN 3-7913-1984-1

Contents

FACT AND FICTION: THE LOVE STORY

The Beggar Woman,
1796–97,
detail of illus. on page 60

The story of Goya's relationship with the Duchess of Alba is one fraught with riddles and mysteries. As early as the nineteenth century it intrigued authors who wrote on the Spanish artist and his work. In the spirit of Late Romanticism, they saw it as a passionate, fateful affair that deeply influenced Goya's life and creative activity. Yet nineteenth-century historians were not the only ones to believe that the Spanish Court Painter and the nation's foremost lady, next to the queen, maintained a scandalous tie across the barriers of social station. Even a modern writer like Lion Feuchtwanger in *This Is the Hour: A Novel about Goya* could not resist the temptation to build his narrative around the affair: "She came, heavily veiled. They did not speak, not even words of greeting. She unwrapped herself from her veil. The warm pallor of her face, unpainted, gleamed in a brownish white. He snatched her to him, dragged her down upon the bed." Thus Feuchtwanger's tempestuous vision of one of the many meetings between Goya and the Duchess of Alba, which, in his eyes, dominated both their lives until her premature death in 1802.[1] Against the background of late eighteenth-century Spain, the novelist paints a picture of love and passion, hate and jealousy, among the Court Painter and the duchess, the queen and her favorite, Manuel Godoy.

The legendary relationship between Goya and the eccentric duchess, evidently one of the most exciting and desirable women in Spain at the time, has left its traces not only in literature and scholarship. Films, too, have been made on the subject. In the 1940s Spanish director Luis Buñuel wrote a script about the famed romance, attributing its breakdown to social inequalities. Buñuel's film, however, was never made. In 1958 Henry Koster made the film titled *The Naked Maja* in which the tragic death of the duchess marked the end of the affair. There followed three movie projects, which shed greater or lesser light on the nature of Goya's relationship with the Duchess of Alba.

It is probably safe to say that invention outweighs a concern for truth in every account of the affair. But where does

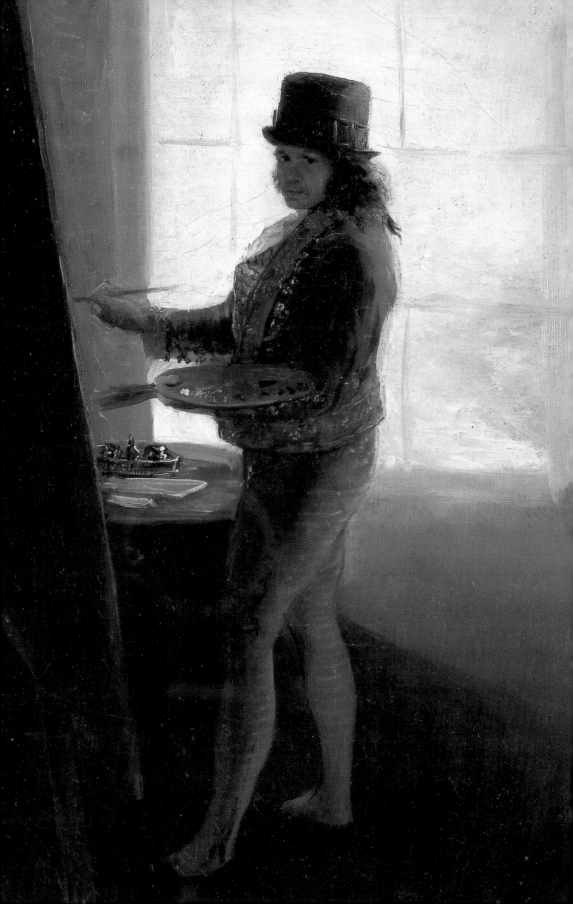

the truth lie? What do we know about this love affair, two centuries past and as piquant as ever? Did it really take place, or was it the product of an overheated Victorian imagination? What happened back then? What documents exist to prove it? And what kind of woman was the Duchess of Alba, who, if the romantic version of the story is to be believed, nearly drove Goya mad?

THE DUCHESS OF ALBA: THE QUEEN'S RIVAL

Self-Portrait in the Artist's Studio, ca. 1790–95, oil on canvas, 16 ½ × 11 in. (42 × 28 cm), Madrid, Real Academia de Bellas Artes de San Fernando

The cherished daughter of María del Pilar and the Duke of Huéscar, María Teresa Cayetana, was raised in a small town by the name of Piedrahita, near Avila. Here, in the northern part of the Sierra, her grandfather, the XIIth Duke of Alba, possessed a grand summer residence with extensive lands, parks, and gardens in the Italian style. (The palace was destroyed in the early nineteenth century.) Yet the family's carefree days were soon to come to an end. Shortly after the Albas moved to the capital at the king's request, María Teresa's father died. The young duke's unexpected death was a terrible blow for her grandfather as well, for he had lost his only son and male heir to the house of Alba. From this point on the elderly duke assumed responsibility for the upbringing of his eight-year-old granddaughter, who would come into the title of the XIIIth Duchess of Alba upon his decease. His views on education derived from Jean-Jacques Rousseau (1712–78), whose writings he studied and with whom he maintained a close friendship. The girl was to grow up wild and free, shielded from all compulsion, to ensure the free unfolding of her mental and physical capacities; adaptation to society must not be allowed to spoil the natural and the emotional side of human nature. Such, at least, declared Rousseau in his didactic novel *Emile*, published in 1762, the year of María Teresa Cayetana's birth. Described by another local resident, José Somoza (1781–1852), as unaffected and high-strung, the future duchess seems to have been everything her guardian could have wished. In Somoza's memoirs of Piedrahita, the author tells

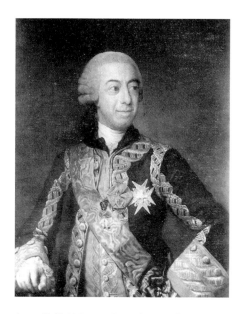 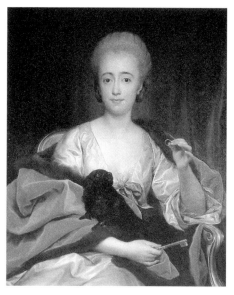

Anton Raffael Mengs, *The XIIth Duke of Alba*, ca. 1774, oil on panel, 33 ½ × 27 ½ in. (85 × 70 cm), Madrid, Collection of the Duke of Alba

Anton Raffael Mengs, *The Duchess of Huéscar*, ca. 1774, oil on panel, 33 ½ × 27 ½ in. (85 × 70 cm), Madrid, Collection of the Duke of Alba

the story of an elderly lady who knew the duchess in her youth. "What vitality! What cheerfulness! And above all, what incredibly lovely hair!" recalled the lady, who once visited María Teresa at the palace, where she found her dressing. "My dearest little friend," the child-duchess is said to have exclaimed impetuously, "if it disturbs you to see me naked, I shall cover myself with my hair." [2] Such childlike naturalness and spontaneity apparently remained salient traits to the end of the duchess's life.

The Albas continued to spend the summer months in Piedrahita, and the rest of the year in Madrid, at Buenavista Palace (today the headquarters of the Spanish Ministry of Defense), which the Duke of Alba had purchased together with the adjacent buildings shortly before his son's death. María Teresa's mother, the Duchess of Huéscar, was an elegant, well-educated woman who was partial to literature and the arts. She translated French comedies and dramas, made accomplished drawings, and was even named an honorary member of the Royal Academy of Fine Arts, in 1766. The girl's grandfather was a music-lover, a patron of young musicians, and a music impresario. Moreover, he amassed one of the foremost painting collections of the period. Sur-

rounded by art and music, María Teresa Cayetana spent the remaining years of her childhood under the protection of her grandfather and her mother, with nurses, maids, and servants at her beck and call.

It was likely a concern for the future of the Alba dynasty that prompted the aging duke to waste no time in seeking a husband for his granddaughter. She had not yet turned thirteen when she was compelled to marry the eighteen-year-old Marquess of Villafranca, on January 15, 1775. Yet not even married life was apparently able to quell the young duchess's impetuous temperament, as indicated by an episode, related by a *señora* of the Somoza family to the historian Joaquín Ezquerra del Bayo. One day, the lady reports, as the duchess and one of her maids were out walking near her Madrid palace, she was approached by a young student, who was unaware of her identity. She suggested they go to an outdoor restaurant, where she proceeded to order everything on the menu that struck her fancy. When the talkative young man realized he would be unable to foot the bill, his words of flattery died in his throat. Yet, laughing and flirting, his companion continued to order more, "until he lets his trousers down!" she reputedly told the proprietor, who knew very well who the capricious young lady was. And so it happened: to the amusement of all, the beau was forced to leave his trousers as security. But that was not the end of the story. On the way home the duchess attempted to cheer up her chagrined admirer, encouraging him to tell her about his goals in life. She promised him that on the following night, his wishes would be granted. The unsuspecting student was taken by a servant to the Duchess of Alba's palace the next night. Here he found himself confronted

Ginés Andrés de Aguirre, *The Gates of San Vicente,* 1785, oil on canvas, 136 ⅝ × 177 ⅛ in. (347 × 450 cm), Madrid, Museo del Prado

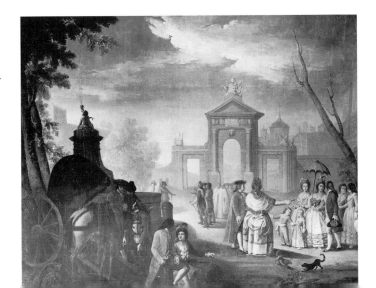

by the young lady from the sidewalk café, who, now clad in robes befitting her station, received him with the intent of keeping her promise.[3]

Whether this incident actually took place as described, we naturally cannot say. Yet, as experience tells us, such anecdotes invariably contain a grain of truth. The Duchess of Alba was known for her great generosity toward the socially disadvantaged, and she was unhampered by snobbery or class prejudice, as her last will and testament amply confirms. Yet, she was also a woman who loved to play the game of seduction. Fleuriot de Langle, a Frenchman who traveled through Spain in the early 1780s, once commented: "The Duchess of Alba possesses not a single hair that does not awaken desire. Nothing in the world is as beautiful as she.... When she walks by, all the

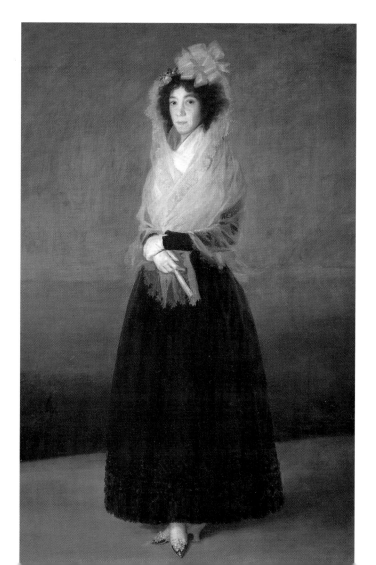

Marquesa de la Solana,
ca. 1794–95,
oil on canvas,
72 ½ × 48 ¾ in.
(183 × 124 cm),
Paris,
Musée du Louvre

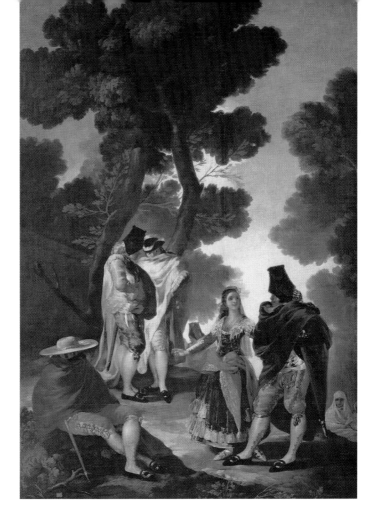

The Andalusian Promenade (El paseo de Andalucía), 1777, oil on canvas, 108 ¼ × 74 ¾ in. (275 × 190 cm), Madrid, Museo del Prado

world stands at the window — even children, who stop playing to gaze at her."[4]

Sadly, no portraits are known of the young María Teresa Cayetana, which would give us an idea of her beauty and sensual magnetism. Even the portrait of the young duchess with her mother — still mentioned in the earlier literature — has been lost. An impression of her grace, however, is conveyed by Goya's *Portrait of the Duchess of Alba in White* of 1795, which depicts her at the age of thirty-three. Her black hair, graceful figure, and haughty gaze underscore the veracity of the French traveler's report.

On one point the numerous descriptions we have of her agree: the young Duchess of Alba was an extraordinarily fascinating woman, owing not only to her beauty but also to her behavior,

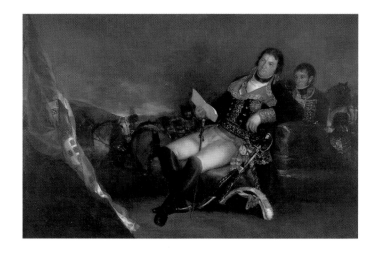

Godoy as Commander in the War of the Oranges, ca. 1801, oil on canvas, 70 ¾ × 105 ⅛ in. (180 × 267 cm), Madrid, Real Academia de Bellas Artes de San Fernando

which struck her contemporaries to no lesser degree. She knew how to move in society; but she was equally adept at breaking its rules. Her unconventionality was not always well received. In a letter of September 11, 1785, the husband of the Marquesa de la Solana, a longtime friend of María Teresa Cayetana, advised his wife to break off relations with her. The duchess's deportment left much to be desired, wrote the count, because "instead of considering what is proper and must be done, she pleasantly whiles away the time at such moments by singing *tiranas* and envying the *majas.*"[5]

Maja was the term used to describe young women of the people, who consciously dressed in traditional Spanish costume. A *maja* wore a mantilla over her head and shoulders, and sometimes a wide sash around her hips. She strolled the boulevards with her girlfriends in this costume, and wore it to dances, festivals, and at other popular entertainments. The *majo* at her side sported a close-fitting vest, a colorful sash, a wide cloak, and a broad-brimmed hat. The streets of Madrid thronged with these picturesque figures, and they were commemorated in many paintings and plays of the day, gossiping or promenading, at dances or at picnics. *Majas* and *majos* embodied a tradition-conscious Spain,

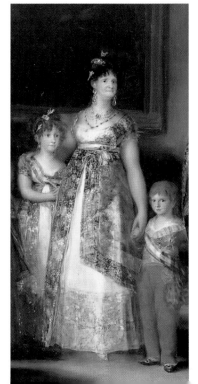

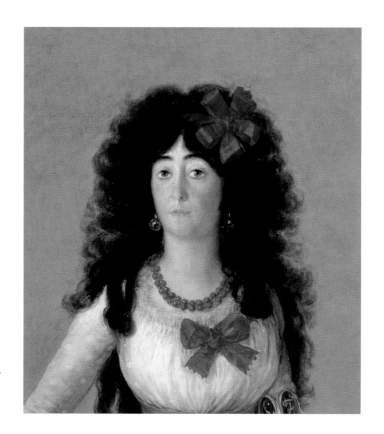

Portrait of the Duchess
of Alba in White, 1795,
detail of illus.
on page 33

which, in the wake of the Enlightenment, had been increasingly
supplanted by French manners and mores. This folk fashion
found many adherents in the aristocratic circles of Madrid as well.
Probably the best known of them was the Duchess of Alba
herself, who was reluctant to show herself in a powdered wig, but
all the more eager to appear in a black mantilla. She loved the
popular festivals, the singing and dancing — the very things the
Marquess had condemned in his letter. Her grandfather had
raised her to be free and insouciant, and so she lived, in the midst
of staid Madrid.

The Duchess of Alba's greatest rival on the social stage was
no one less than the Queen of Spain, María Luisa of Parma.
Wilhelm von Humboldt, on his journey through Spain in
Family of Charles IV,
1800–01,
detail of illus.
on page 79
1799–1800, described the queen as being "likely more educated"
than her spouse, Charles IV, but "frightfully ugly."[6] That von
Humboldt was not exaggerating overmuch we know from Goya,

who captured the distinctive features of the Spanish queen in numerous portraits.

María Luisa, too, was known for her amorous adventures. Her most famous, and for Spanish history most momentous, affair was her relationship with the young Manuel Godoy. Owing to her patronage, from 1784 Godoy rose meteorically at court, advancing from ordinary cadet to Duke of La Alcudia. Later he even managed the business of government for the politically weak Charles IV. Still, though he also had an affair with the Duchess of Alba, Godoy was not the cause of the enmity between the two women.

In a thin volume only a few copies of which now survive, written by Pierre Nicolas Chantreau and published in 1793 in Madrid, we find descriptions not only of the political life of the Queen of Spain but of her "amorous intrigues with the Duke of La Alcudia and her jealousy of the Duchess of Alba." The book also contains the following story about Juan Pignatelli, an army officer who in the years around 1780 stood between the two most powerful women in Spain.

According to Chantreau, who lived in Madrid prior to 1784, Juan Pignatelli was in love with his stepsister, the young Duchess of Alba. She, however, resisted his advances with a certain obstinacy. Not so María Luisa, then Princess of Asturias, who took an interest in the young officer. As a token of her affection she presented him with a golden box, inlaid with diamonds. María Teresa, after a long and tender siege on the part of her step-

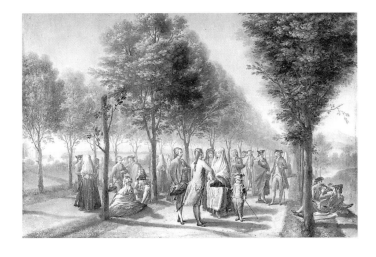

Francisco Bayeu,
El paseo de las Delicias,
ca. 1785,
oil on canvas,
14 $\frac{1}{2}$ × 21 $\frac{5}{8}$ in.
(37 × 55 cm),
Madrid,
Museo del Prado

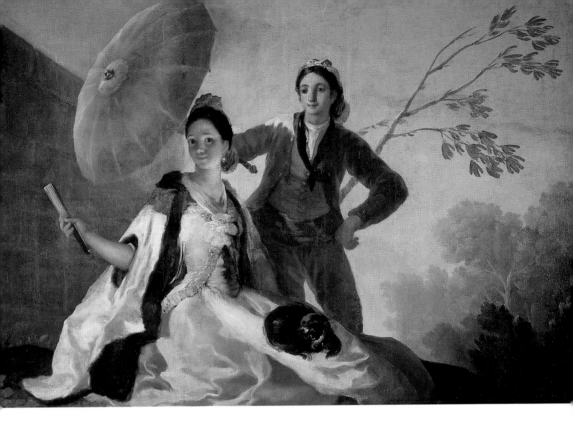

The Parasol (*El quitasol*),
1777,
oil on canvas,
41 × 59 ⅞ in.
(104 × 152 cm),
Madrid,
Museo del Prado

brother, finally gave in, but not without demanding proof of his love: her rival's gift in exchange for a diamond ring. When the princess saw María Teresa's ring on Pignatelli's finger, she in turn demanded it as a present, intending to shame her rival at the next official hand-kissing ceremony. But the duchess would not be provoked, breaking off with her lover instead. The second part of the story, related by Chantreau in as much scandalous detail, concerns the duchess's attempts to take revenge, which did not end until the king, at his son's behest, relieved María Teresa Cayetana of all her duties at court.[7]

There is no way of knowing whether this love-hate triangle in fact played out as Chantreau described. Yet its existence is evidence enough of the rivalry between the two *grandes dames* of Spanish society, evidence confirmed by further anecdotes from Chantreau's pen. Lady Holland, who lived in Spain from 1802 to 1805, had similar observations to report. In her *Spanish Journal*, she wrote: "The Dss. was always an object of jealousy and envy to the great Lady; her beauty, her popularity, grace, wealth, and rank were corroding to her heart."[8]

The open love affairs of married female courtiers may aston-
ish us today, but in the reign of María Luisa and Charles IV it
was quite common for married women to appear in public
with other men. "As soon as a lady marries, she is teased
by numerous competitors for this distinguished favour, till she
is fixed in her choice," reported the English traveler, Joseph
Townsend, in 1786–87.[9] As soon as she had indicated her pref-
erence, the others retired. The *cortejo*, as the lucky one was
known, courted his lady openly — they appeared together in
public, went to the theater, parties, concerts. As for instance
the Duchess of Osuna, who in 1784 was escorted by her *cortejo*
to a reception in honor of the Portuguese ambassador. The *cor-
tejo* was an established institution among married noblewom-
en during the latter half of the eighteenth century. He was
tolerated by society as by husbands, who knew that apart from
taking his pleasure the *cortejo* had certain obligations to fulfill,
principally of a financial nature. Gowns, jewelry, or gifts — what-
ever his lady's heart desired, must be granted. Seen in this light,
it cannot have been an easy task to serve as *cortejo* to a capri-
cious lady in an era when women of rank were veritably ob-
sessed with luxury. Whether or not the *cortejo* fulfilled purely
social functions was probably difficult to say in the individual
case. For obvious reasons this tended to remain the secret of
those concerned. Hence to this date we do not know what role
Juan Pignatelli really played in the intrigues spun out by the two
young ladies, duchess and queen. Was he consort or paramour, or
perhaps merely the plaything of two women who felt like amus-
ing themselves at a man's expense?

The Duchess of Alba loved entertainments and diversions.
She neither concerned herself with the social issues of the day,
like the Duchess of Osuna, nor did she play a role in political
affairs, like her rival the Queen of Spain. The life of María Teresa
Cayetana, if her contemporaries' reports can be believed, con-
sisted primarily of society gossip, amours, and infringements of
whatever convention piqued her. Today we would probably know
very little if anything about this woman, had she not met Fran-
cisco de Goya.

Goya's letter to Martín Zapater,
"London 2 August 1800."
(1794),
Madrid, Museo del Prado

"Yesterday she came to the studio..." – The First Meeting

"His knees shook. Every hair, every pore of her skin, the thick arched eyebrows, the breasts half exposed under the black lace, aroused in him unbounded desire." So Feuchtwanger envisions the fateful encounter between the painter Francisco de Goya and the Duchess of Alba, at one of the grand festivities at Buenavista Palace, in the year 1793.[10] According to the novelist, the two had met several times before, and Goya had even painted a portrait of the duchess. But he did not really see her until that night: "She was sitting, following the old custom, on a low dais spread with rugs and shut off from the rest of the room by a small grille with a wide opening. And she was not wearing a modern gown like the other ladies, but a Spanish one of old-fashioned cut.... He stood there without a word and stared foolishly at the Duchess." One would be tempted to accept the author's imaginative reconstruction at face value, were it not for certain details at the beginning of the novel that give reason to doubt its historical accuracy. In 1793, for instance, when the French monarchs Marie-Antoinette and Louis XVI were executed in Paris, Goya was not forty-five years old, as Feuchtwanger writes, but already forty-seven. Also, despite the novelist's assurance to the contrary, there is no known portrait of the Duchess of Alba from Goya's hand prior to 1795. These inconsistencies, unimportant in the context of a novel, do carry more weight when trying to determine when, in fact, Goya first met the Duchess of Alba.

The earliest document to confirm a meeting is a letter that Goya wrote to his friend Martín Zapater in Saragossa, in which he describes a visit of the duchess to his studio. She came, Goya relates, "to the studio yesterday, to have her face painted, and so she left it; I must say I like it better than painting on

Francisco Bayeu, 1786,
oil on canvas,
42 $^1/_8$ × 31 $^1/_2$ in.
(107 × 80 cm),
Valencia,
Museo provincial
de Bellas Artes

canvas."[11] Goya's preference for the face of the Duchess of Alba
is understandable, as it was surely not only an aesthetic pleasure
but a great honor for the royal court artist to be asked to make
up the first lady of the court, next to the queen. The letter
is dated "London 2 August 1800." This means that María Teresa
Cayetana must have visited Goya in his London studio the
previous day. Yet Goya was never in London, nor did he
ever have a studio there. From the rest of the letter we may
infer that it was written between July 1794 and August 1795,
because Goya mentions his teacher and brother-in-law, Fran-
cisco Bayeu, saying that ill health had compelled him to move to
Saragossa. We know that on July 14, 1794, Bayeu requested the

Self-Portrait,
ca. 1771–75,
oil on canvas,
22 $^7/_8$ × 17 $^3/_8$ in.
(58 × 44 cm),
Madrid,
private collection

king's permission to travel to Saragossa, and that he died there on August 4 of the following year. Consequently, Goya probably wrote this letter on August 2, 1794. This implies that he had already been in close contact with the Alba family since the summer of 1794, as the duchess's request attests to a certain familiarity with the Spanish Court Painter. By this time Goya had already received the commission to execute lifesize portraits of the Duke and Duchess of Alba. The *Portrait of the Duchess of Alba in White* is already mentioned in this letter to his friend.

Whether or not "painting her face" was the true reason for the duchess's visit, we shall likely never know. Another unresolved question is why Goya should have falsely dated this particular letter, which now represents the earliest record of his involvement with her. Could it be that a love affair was already beginning between him, the royal Court Painter, and her, the second lady of the nation, an affair as unreal and fantastic as the dating of the letter?

There can be no doubt that the August 1, 1794, meeting in his studio was not the first between artist and model, for Goya seems not to have been particularly surprised by the great

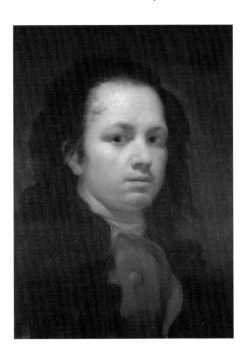

lady's visit, to which he sadly devotes only a few lines. Feuchtwanger and many other authors agree that their paths must have crossed at an earlier date. Goya and his wife, Josefa Bayeu, sister of Court Painter Francisco Bayeu, had been living in Madrid since 1774. At that time Goya was twenty-eight, Josefa twenty-seven. They had known each other since their childhood years in Saragossa. As newlyweds they lived in the house of Goya's brother-in-law Francisco, through whose advocacy Goya was called to the court before the year came to a close. It was the beginning of an auspicious career.

Shortly after Goya was named Court Painter, Madrid witnessed a glorious double wedding, which would have caught the young, ambitious painter's

attention: on January 15, 1775, María Teresa Cayetana married the eighteen-year-old Marquess of Villafranca. Her mother, too, widow of the Count of Huéscar, walked to the altar again that same day. She wed the considerably older Joaquín Pignatelli, Count of Fuentes, who brought four sons into the marriage (including Juan, who Chantreau tells us had an affair with María Teresa Cayetana). Joaquín Pignatelli was the head of the Aragonese family of that name, which had distinguished itself by patronage of writers and artists. The painter José Luzán Martínez of Saragossa, Goya's first teacher, had been furthered by them. For the impoverished Count of Fuentes, marriage to the widowed Countess of Huescár opened new possibilities of patronage. Perhaps Goya knocked on Pignatelli's door shortly after 1775, to introduce himself to the art-loving count as freshly named Court Painter and former pupil of José Luzán. Here he could have met the young María Teresa Cayetana. Goya's close

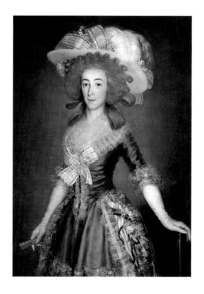

The Duchess of Benavente-Osuna, 1785, oil on canvas, 41 × 31 ¹/₂ in. (104 × 80 cm), Palma de Mallorca, Bartolomé March Servera

friend Zapater also maintained contact with the Pignatelli family. He knew the count's brother, Canon Ramón Pignatelli, who blessed the double marriage of the Albas in Madrid. (Goya portrayed the clergyman in 1790-91.) A connection between Goya and the House of Alba, through the Pignatellis and his friend Zapater, is therefore conceivable indeed. However, commissions from the house of the Count of Fuentes to Goya are not recorded. The elderly count died only a year after his wedding.

From today's vantage point, Goya did not have a second opportunity to meet the Albas until many years later, in 1786, when the Duke and Duchess of Osuna commissioned the now recognized artist with the decoration of their country house, La Alameda. For Goya the years around 1786 were a happy period: in 1784 his son, Francisco Javier, was born, in 1785 he was appointed Deputy Director of Painting at the Royal Academy of Fine Arts in Madrid, followed in 1786 by an appointment as Royal Court Painter to Charles III. In the meantime he had become the favorite artist of the Spanish families represented at court, including the Osunas, who regularly supplied him with commissions from 1785 onwards. The Duchess of Osuna, alongside the Duchess of

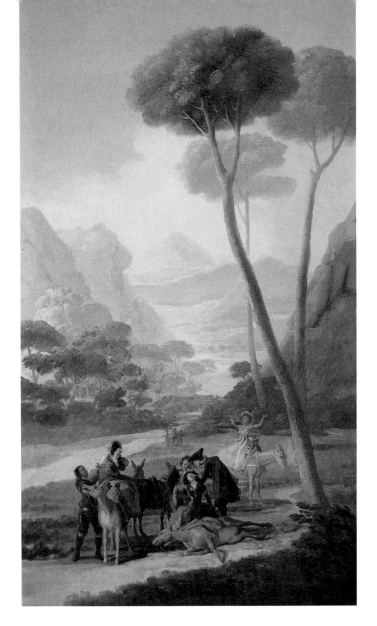

The Fall (La caída),
1786–87,
oil on canvas,
66 ¹/₂ × 39 ³/₈ in.
(169 × 100 cm),
Madrid,
private collection

Alba, was one of the most famous and witty women of the day.
As president of the Women's Section of the Economic Society of
Madrid, she supported many actors, bullfighters, and artists, in-
cluding Goya. She was neither as capricious nor as attractive as
her social rival, but she more than made up for it by intelligence
and elegance. The Duchess of Osuna never dressed in the *maja*
mode, preferring French fashions, as seen in Goya's portrait of
the year 1785.

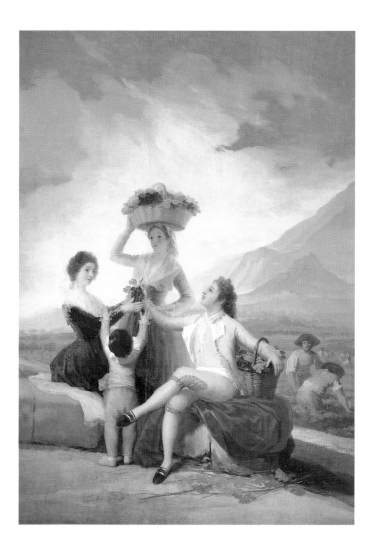

As the invoices indicate, between 1786 and 1787 Goya painted for the Duke and Duchess of Osuna a cycle of seven canvases with pastoral scenes, intended for their country house, La Alameda. The Osunas were not merely the artist's patrons but maintained contact with him, as a letter of August 23, 1786, shows. In it Goya tells his friend Zapater of a hunting outing undertaken with the Marquess of Peñafiell, the later Duke of Osuna.[12] The Duchess of Alba also had friendly ties with the Osunas, visiting them frequently at their country residence. As the house inventory records, she even had her own donkey at La Alameda,

on which she went out riding with the Duchess of Osuna.[13] One of the seven paintings Goya did for the Osunas' country house depicts just such an outing with donkeys, in a rural setting. One of the animals has stumbled, the incident that gives the picture its title. Early twentieth-century art historians claimed to have detected a resemblance between the Duchess of Alba and the unconscious young woman, and between none other than Goya and the man supporting her from behind. It cannot be excluded that Goya may have been inspired to the composition by an actual event, even perhaps one he himself had experienced during one of his stays at La Alameda. Yet whether the duchess suffered the accident depicted, and the extent to which the young lady in the painting resembles her, remains a matter of individual interpretation. What is certain is that the duchess had the opportunity to admire Goya's painting cycle first hand at La Alameda. And it is quite possible that the two encountered each other at one of the opulent parties regularly held at the house.

Almost concurrently with the paintings for the Osunas' country house there emerged what is perhaps the loveliest series of cartoons (1786–88) Charles III had ordered from Goya to that point. It included a series of seasons, intended for the dining hall of the royal residence and now in the Prado in Madrid. In the depiction of autumn, *The Vintage* (*La vendimia*), we see a young couple dressed in fine costume, seated on a stone bench in the middle of a field. A small boy and a young woman keep them company. In the view of some historians who wrote about Goya and the Duchess of Alba early in the present century, the couple represent the Duke of Alba and his wife, who sat to Goya in the expanse of the Piedrahita countryside, accompanied by Josefa Bayeu, the artist's wife, and their son, Javier. We do not know what Josefa looked like in her younger years, since only a single portrait drawing of her exists, depicting her at age fifty-eight. The boy in the picture, at all events, cannot possibly represent Javier, because in the summer of 1786 he was not yet two years old. Nor is the supposed similarity of the couple to the Albas in the least convincing. The most one can say is that Goya might, once again, have let himself be inspired by a scene actually observed.

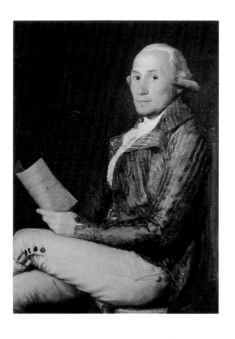

Don Sebastián Martínez y Pérez, 1792, oil on canvas, 36 $\frac{1}{2}$ × 26 $\frac{5}{8}$ in. (92.9 × 67.6 cm), New York, Metropolitan Museum of Art

During those years the Albas usually spent the summer months in their country house in Piedrahita, near Avila, where María Teresa Cayetana spent the first years of her childhood. If Goya really did make the acquaintance of the Duchess of Alba at the Osunas' summer home in 1786, it is not hard to imagine that she might have invited him, perhaps with his family, to her own summer residence that same year. Feuchtwanger's novel, at any rate, has Goya spending several weeks in Piedrahita. Here, in its rural mountain scenery, he might very well have found impressions and inspirations for the composition of the four cartoons, which, before proceeding to the final execution,

Goya captured in small-format oil sketches. On closer scrutiny, the landscapes in *The Vintage* and *Spring* (*Las floreras*) do in fact bear a certain similarity to the region around Avila.

So between 1774, the year Goya moved to Madrid, and the summer of 1794, when María Teresa Cayetana came to his studio, several opportunities for an encounter between the two indeed may have arisen. One very likely place was the home of the Countess of Altamira, the duchess's sister-in-law, who sat with her little daughter María Agustina to Goya in 1787–88.

Goya's First Journey to Andalusia

Mystery still enshrouds Goya's first journey to Andalusia in the winter of 1792–93, which was to change his life radically. That winter, believed nineteenth-century authors, Goya precipitately followed the Duchess of Alba to southern Spain, where she had a summer house not far from Cadiz. Here, in Sanlúcar de Barrameda, that passionate and fateful love affair between artist and noblewoman reputedly began. But what do the sources have to say?

We know that Goya left Madrid without official permission to travel to Andalusia in November 1792. As Court Painter he was in a sense a royal official who could not take leave of the court without his superiors' consent. From a letter written by his friend Zapater, dated January 11, 1793, we gather that Goya lay ill in bed in the house of the merchant Sebastián Martínez y Pérez in Cadiz. That he had been there quite some time is evidenced by a portrait of his friend and host dated 1792. It shows the approximately forty-five-year-old Martínez, clad in the French fashion, with powdered wig and frilled shirt. In his left hand he holds a sheet of paper with writing, which translates "D. Sebastian Martinez from his friend Goya 1792." Goya likely painted this portrait in the last weeks of the year 1792, either before or during the illness which was to render him incurably deaf. His illness was probably also the reason for delaying his return to Madrid. Goya's absence from the capital did

not go unremarked. In order to ensure further payment of his Court Painter's salary he had to request official leave after the fact. Through Martínez's intervention, two months were finally granted him in January 1793. In the words of the official grant, "The King has the kindness to accord Francisco de Goya permission to remove for two months to Andalusia in order to recover his health there."[14] Probably owing to a lack of funds, Goya concurrently attempted to obtain an advance from the Duke of Osuna. In a letter to the ducal superintendent, which he falsely dated "17.1.1793 Madrid" in order to cover up his absence from the capital, Goya excused his request by referring to his poor health. He had spent, he wrote, "two months in bed with painful colics ..." and was now "preparing, with permission, to travel to Seville and Cadiz," whereupon the Duke of Osuna sent 10,000 reales to Seville.[15] Thus Goya also tried to make the Duke of Osuna believe he was still in Madrid, and would not leave until he had obtained official permission. His mention of being confined to bed for two months was presumably intended to explain why he had not been seen in public during that period. But why this game of hide and seek?

When he left Madrid in November 1792, Goya surely did not intend to stay long in Andalusia. His illness, however, delayed his return to the capital. Therefore he initially had to make every attempt to keep his unsanctioned trip to Andalusia secret, which, with the help of his friends, he succeeded in doing. Goya's host, Martínez, even formally requested an extension of leave for his patient, in a letter of March 19, 1793. By the middle of March the artist was at last on the road to recovery. On March 29 Martínez wrote to Zapater in Saragossa, "Friend and Sir: It is a bad day to write, but I shall not neglect, in reply to your esteemed of the 19th, to report that our Goya is slowly beginning to recover. I trust to the season and the baths.... The ringing in his head and the deafness have not yet lessened, but he is looking much better again and no longer suffers from disturbances of equilibrium. He can get up and down the stairs very well now and is again doing things he had been unable to do."[16]

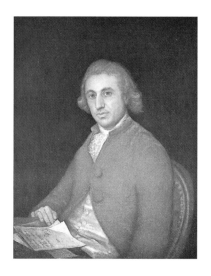

Martín Zapater, 1790, oil on canvas, 32 ⅝ × 25 ⅝ in. (83 × 65 cm), private collection

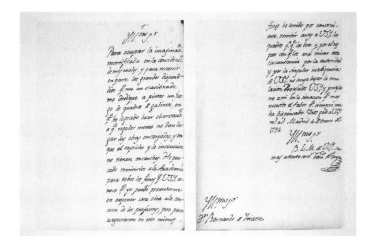

Many authors, including medical doctors, have tried to diag-
nose Goya's malady on the basis of the symptoms described here.
No final consensus has been reached; among the causes discussed
have been syphilis, sudden loss of hearing, embolism, and lead
poisoning, this last as a result of the high lead content of the
paints Goya used.

Like his illness, the reason for this trip has remained unex-
plained, giving rise to wild speculation. It was once widely be-
lieved that Goya had a secret tryst with the Duchess of Alba
in the seclusion of her summer estate at Sanlúcar de Barrameda.
But this hypothesis, a product of the romantic spirit of the nine-
teenth century that still has adherents today, finds no evidence
to support it. On the contrary, there are a few documents
that speak against it. In the first place, the Alba palace in San-
lúcar de Barrameda was leased to the Archbishop of Seville
from 1789 to 1795. Hence a reunion between Goya and the
duchess could only have taken place at the small, isolated
country estate El Rocio (The Dew), located between Seville
and the Atlantic coast. However, as we know from the sources,
María Teresa Cayetana stayed in September and October 1792
at her country house in Piedrahita, in order to recover from a
serious illness. On November 2 she was back in Madrid; shortly
thereafter she met her husband at the Escorial. In early Decem-
ber the duchess returned alone to the capital. Thus it could not
have been Goya who followed the duchess, but the duchess who

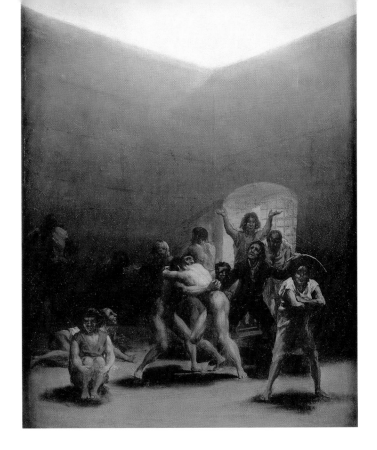

*Yard with Lunatics
(Corral de locos)*,
1793–94,
oil on tinplate,
17 ¹/₄ × 12 ⁷/₈ in.
(43.8 × 32.7 cm),
Dallas, TX, Southern
Methodist University,
Meadows Museum
and Gallery

followed the ailing Goya to Andalusia — a very bold hypothesis
indeed!

Perhaps when he left Madrid in November 1792 Goya in-
tended merely to make a brief visit to his friend Sebastián
Martínez in Cadiz, to paint his portrait and to see his famous
art collection with its more than 300 paintings and several
thousand works of graphic art. Or he was on his way to Seville
to look at Santa Cueva Church, which at the time was still
under construction, since he had been commissioned shortly
before to execute three paintings for its decoration. Or perhaps
he merely wished to spend a few leisurely days in Andalusia.
Whatever the case, one thing would seem beyond doubt: the
Duchess of Alba was not the motive for Goya's journey.

In the spring of 1793 Goya returned to Madrid. Despite his
deafness he gradually, and with renewed powers, resumed his
artistic activity. Proof of this lies in the creation of the group
of what he called "cabinet paintings." This is how Goya de-
scribed them to the Vice Protector of the Royal Academy of

Fine Arts, Bernardo de Iriate, in his famous letter of January 4, 1794: "To occupy my imagination, mortified in consideration of my ills, and to recuperate in part the great expenses that they have caused, I devoted myself to painting a set of cabinet paintings, in which I have realized observations that are usually not permitted by commissioned works, and in which caprice and invention have no greater extension."[17] "Capricho" (caprice or fantasy) and "invención" (invention or imagination) were the great artistic wellsprings Goya now tapped. They provided the source of a new world of imagery that oriented itself less to observed reality than to the realities of an inner vision, which had revealed themselves to Goya during his physical and mental suffering of the foregoing months. Yet the events of these winter months of 1792–93, which so profoundly influenced not only Goya's life but also his art, remain shrouded in enigma.

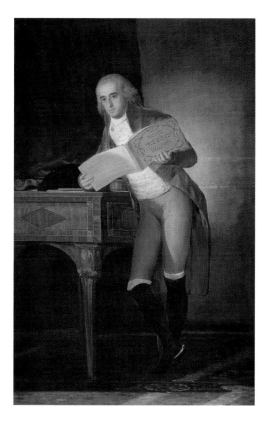

The Duke of Alba, 1795
oil on canvas,
76 ³/₄ × 49 ¹/₂ in.
(195 × 126 cm),
Madrid,
Museo del Prado

The Portrait of the Duchess of Alba in White

She stands there entirely in white, the Duchess of Alba. The red sash pulled tight around her waist very purposely emphasizes the slenderness of her figure. The black, curly hair around her pale face falls untamed to her shoulders. She gazes at us from large dark eyes, commandingly, almost superciliously, an impression underscored by her straight, self-confident posture. At her feet stands, all fawning attention, her little white dog, adorned with a red bow that seems a grotesquely comic version of the one she wears on her bodice. With her right hand the duchess directs our attention to the inscription in large letters below: "To the Duchess of Alba Fr.co de Goya 1795."

The portrait was done during the months following the duchess's visit to Goya's studio, as we may gather from the letter dated "2 August 1800" (cited above) that he wrote to his friend Zapater. María Teresa Cayetana was thirty-three at the time, and was living with her husband Don José in Buenavista Palace, in the heart of Madrid. Don José de Toledo, unlike his wife, was quiet-tempered. He loved classical music, was partial to Haydn, and played the violin. This is how Goya depicted him in his portrait, which was likely intended as a companion piece to the *Portrait of the Duchess of Alba in White*. Unlike the duchess, the duke does not stand in an open landscape, but in a confined if vague interior space, leaning on his clavichord (see illus. on page 31). On it, partly concealed by the encroaching darkness, lies his violin. In his hands he holds a work by Joseph Haydn. Goya composed both paintings so subtly that gaze and bearing of the sitters alone wonderfully characterize the difference between their personalities: self-confidence, pride, and hauteur versus gentleness, sensitivity, and melancholy.

In the year 1795, when the two portraits were executed, the duke and duchess had been married for twenty years. They respected each other but went their separate ways, as was commonly the case at that period, when people wed for life but rarely for love. Marriage tended to be a community of interests, with rights and duties that were dictated by social convention. But the Albas were unable to fulfill what at that period was likely the most important marital duty of all. Their marriage

Portrait of the Duchess of Alba in White, 1795, oil on canvas, 76 ³/₈ × 51 ¹/₈ in. (194 × 130 cm), Madrid, Collection of the Duke of Alba

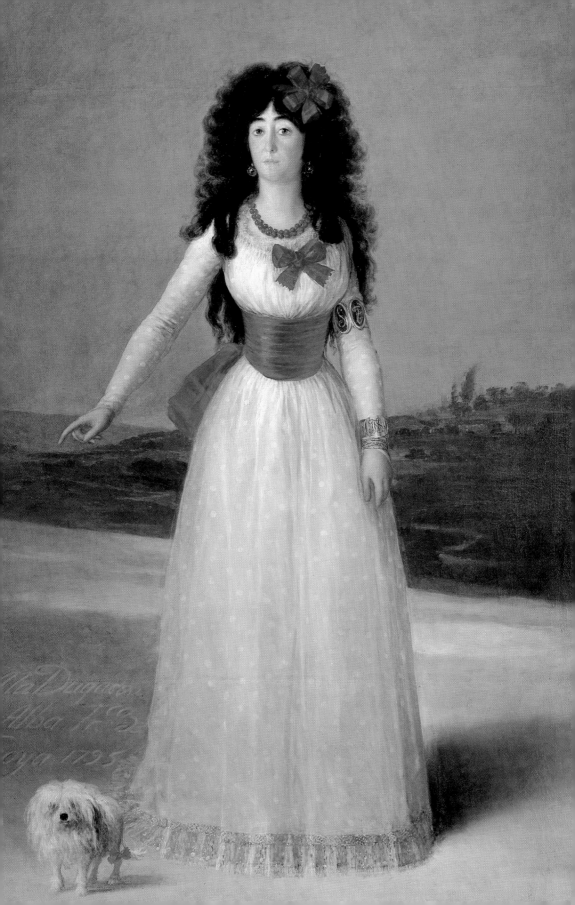

remained childless. The obligation to present her family with an heir weighed heavy on the mind of the XIIIth Duchess of Alba from an early date, because after her father's early death it was clear that, being his only child, she would inherit from her grandfather the ducal title, which had been in the possession of the Alvarez de Toledo family for generations. A young male heir was probably the unspoken hope of her grandfather Don Fernando, XIIth Duke of Alba, when he married off María Teresa at age twelve in 1775. Yet the young woman was unable to grant his wish, a fact to which some twentieth-century psychologists have retrospectively attributed to the duchess's extroversion, capriciousness, and infantility.

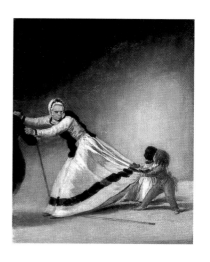

Nevertheless María Teresa loved children, and even adopted a little black girl by the name of María de la Luz, who lived with her in Buenavista Palace. On a drawing of Goya's done in 1796–97 she holds the girl tenderly in her arms. Luis Berganza, her caretaker's son, whom she affectionately called Luisito, was also very close to the duchess's heart, as a letter from her hand proves: "Beloved and dear Luisito of my life," she wrote. "Your letter gave me much joy, and even more the certainty that you are diligent and endeavor to give me the consolation of being a good boy. The girls send you regards and an embrace with my whole heart, my dear son"; signed "J. María Teresa de Silva."[18] Goya's brush captured little Luisito as well. The small-format painting executed in 1795, the same year as the *Portrait of the Duchess of Alba in White*,

Maid in Waiting with María Luisa and Luis Berganza, ca. 1795, oil on canvas, 12 1/4 × 9 7/8 in. (31 × 25 cm), Madrid, Collection of Berganza de Martín

Letter from the Duchess of Alba to Luis Berganza, private collection

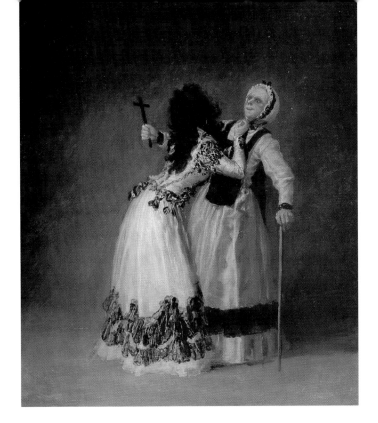

shows Luisito and María de la Luz playing with an older woman. She is probably the housekeeper, Rafaela Luiza Velázquez, known as "la Beata," which means something like "lay sister," a nickname probably given her because she prayed so much. During the days Goya frequented the Albas' palace he painted another small picture, which gives us an impression not only of life in the grand house but also of the vivacity of the duchess, who apparently enjoyed playing pranks on the maid as much as the children did.

The quiet, retiring Don José was apparently somewhat helpless in face of his wife's impetuous temperament. He shared this plight with many other Spanish husbands in the late eighteenth century, when Spanish women began to liberate themselves from the bonds of social norms. Instead of living quietly in the protection of their home, as for centuries they had been expected to do, they now increasingly met for a stroll or a carriage ride together. They showed themselves in public, with their new gowns or their latest *cortejos*, the prime status symbol of married ladies of rank. Meeting for a chat at friends'

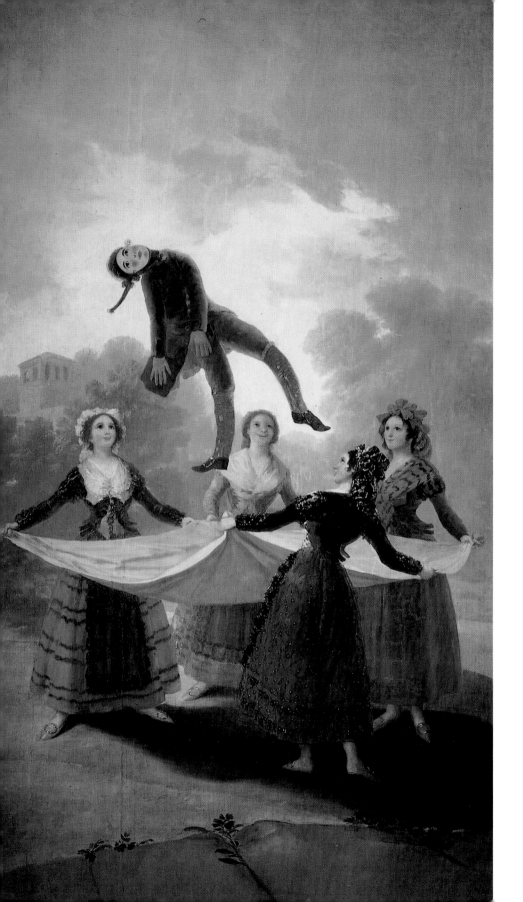

or one's own house, an occasion known as a *tertulia,* also became extremely popular. In fact this socializing was considered veritably revolutionary, for in the seventeenth century home and family were viewed as a sanctum that brooked no intrusion from outsiders. Spanish noblewomen, foremost among them the Duchess of Alba, enjoyed their newfound freedoms to the full. They arranged parties, indulged in luxury and pleasure, and all this without their husbands, as seemed a matter of course at that period. Thus, as a contemporary reported, "the wife went to the one amusement and the husband to the other." Their common home, we learn, served only for "sleeping, eating, and changing clothes." [19] And "when a husband wishes to have his authority respected and tries to bring order into his house," another contemporary author explains, "he makes himself a general laughingstock." [20] The wives let themselves be pampered by their *cortejos,* who were no less at the mercy of their whims than their husbands. Women dominated social life in the aristocratic circles of late eighteenth-century Spain, while men tended to play a subordinate role, an example set by the royal couple, Charles IV and María Luisa. Goya's painting *Straw Mannequin* (*El pelele*) of 1791–92, one of a series of cartoons intended for the tapestries in the royal study at the Escorial (which remained unfinished owing to Goya's serious illness in 1792–93), can perhaps be seen as an allusion to the helplessness of men subject to women's caprices in the perennial game of the sexes.

Life at the Albas' palace, then, reflected the customs of the era. While the duke devoted himself to music, the duchess devoted herself to amusement. María Teresa Cayetana throve on diversion. She enjoyed herself at the court, but also among the common people. She had become the talk of all Spain when Goya met her, in the summer of 1794. His task was to paint her portrait. [21] The result, the *Portrait of the Duchess of Alba in White,* certainly betrays the capricious personality of his model.

Straw Mannequin
(*El pelele*), 1791–92,
oil on canvas,
105 ⅛ × 63 in.
(267 × 160 cm),
Madrid,
Museo del Prado

The royal couple, Charles IV and María Luisa, planned to travel to sunny Andalusia in the winter months of 1796, most likely to escape the cold that usually prevails in Madrid at this season. The Duke of Alba, Don José, had likewise decided at the beginning of the year to leave Madrid. On January 23 he participated in a final official session. Just a few days later he authorized his wife María Teresa to manage the administration and affairs of the house while he was gone. Convinced he had arranged all important matters in Madrid, the duke left for Andalusia. The duchess remained behind, perhaps thinking it would be a graceful way to avoid encountering the queen. It would be the Albas' last farewell.

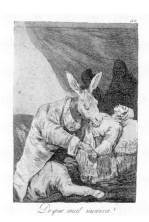

De que mal morira?

In mid-February Charles IV and María Luisa reached Seville, where, it is now generally assumed, the Duke of Alba awaited them. On February 29, probably in the company of the duke, they left for Cadiz, arriving there on March 2. The king and queen could not have sojourned in Andalusia very long, because by March 22 their entourage had assembled again in Aranjuez. The Duke of Alba, however, did not return to the capital, but remained in Andalusia, perhaps for reasons of health.

María Teresa Cayetana spent the winter months in Madrid. In April and May she held grand festivities at Buenavista Palace, including theater performances in which she herself played a small role. No news came from Andalusia, until June 9, the day on which the Duke of Alba died in the early hours, at the age of thirty-nine, in Seville. The embalming took place before the end of the day, owing to the heat and to what the doctors laconically described in their report as "the malady," without going into further detail. Those who were present included Padre Ramón Cabrera and the Albas' chief estate supervisor, Tomás de Berganza. The duchess's name is not mentioned in the sources. The funeral was held the very next day, at San Isidoro del Campo, a church in Santiponce outside Seville. Who paid the last honors to the duke remained unrecorded. Nor has it

Of What Ill Will He Die? (*De que mal morira?*), No. 40 of the *Caprichos*, 1797–98, etching, burnished aquatint, drypoint and burin, 8 ¹⁄₂ × 6 in. (21.6 × 15.2 cm)

since been determined whether the Duchess of Alba actually reached Seville in time to spend her husband's final hours together with him.

That she might have done so can be inferred from what is generally considered to be a small preliminary drawing for *Of What Ill Will He Die?* (*De que mal morira?*) entitled *Brujas disfrazadas en fisicos comunes*, which depicts a scene at the deathbed of a sick man.[22] Two donkeys in human attire sit near the man's bed. While the one holds his hand, the other, completely ignoring his

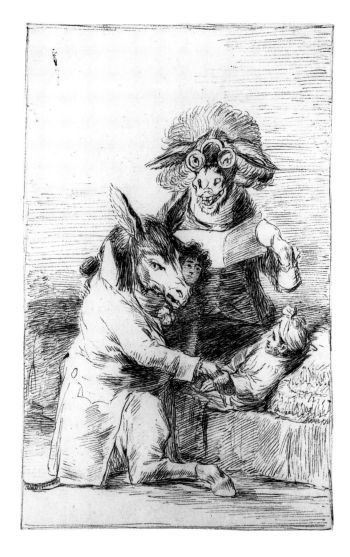

Brujas disfrazadas en fisicos comunes, preliminary drawing for *Of What Ill Will He Die?*, pen and sepia ink, 9 $\frac{1}{2}$ × 7 $\frac{1}{4}$ in. (24.2 × 18.3 cm), Madrid, Museo del Prado

patient, reads from a volume that apparently represents a compendium of medical wisdom. Only the shocked look on the face of the young woman peeping out between the bodies of the donkey-doctors tells us that the young man is about to die.

Of What Ill Will He Die? is the title of No. 40 of Goya's *Caprichos*, a series of eighty etchings first published in February 1799. Here, too, a man marked by pain and suffering lies on his bed, beside him a donkey sympathetically holds his hand. Although the drawing is thought to be a preliminary study for this etching, the final version does not include a second donkey, nor — and especially — does it include the young woman, who bears a great and, considering the historical circumstances, perhaps not entirely coincidental resemblance to the Duchess of Alba. Might Goya have been alluding to that day in early June 1796 when the Duke of Alba lay on his deathbed in Seville, surrounded by his wife and two charlatans, who were unable to save his life? The Albas' family doctor, Jaime Bonells, was probably not present at the time; but, one might conclude from Goya's drawing, María Teresa Cayetana was, and that she was helpless in the face of the two donkey-doctors' omniscience. Might they perhaps even have been to blame for the duke's premature death? If the drawing can indeed be interpreted as a direct reference to this event, how did Goya know about it?

A letter of July 22, 1796, written by the Aragonese sculptor Arali, a friend of Goya, to Ceán Bermúdez in Seville, confirms that Goya was in fact in Seville or in Sanlúcar de Barrameda at this time, more precisely, on May 25. But what was the artist doing in Andalusia in spring 1796? So much is clear: despite the legend, this journey to the sunny south, like the previous one, was not undertaken out of undying love for the Duchess of Alba, simply because she was still in Madrid at the time. It is conceivable, however, that Goya traveled to Seville in order to execute the three large paintings for Santa Cueva Church, which his illness during his previous stay in 1792–93 had prevented him from doing. Possibly Goya even traveled at the beginning of the year to Andalusia, together with the Duke of Alba and the royal couple, to whom he was obliged as Court Painter. At any rate, an

The Duchess of Alba Arranging Her Hair, 1796–97 (Sanlúcar Album), india ink wash, 6 ¾ × 4 in. (17.1 × 10.1 cm), Madrid, Biblioteca Nacional

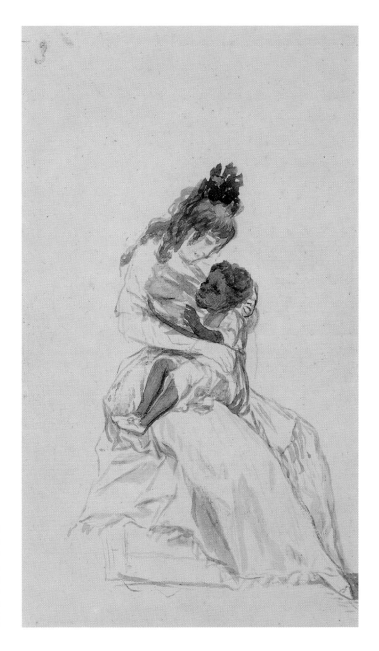

official document confirms that the artist was "absent [during] the entire year of 1796 and was in Seville."[23] Goya presumably also maintained contact with the Duke of Alba during this period, for why else should he have traveled to Sanlúcar de Barrameda, as his

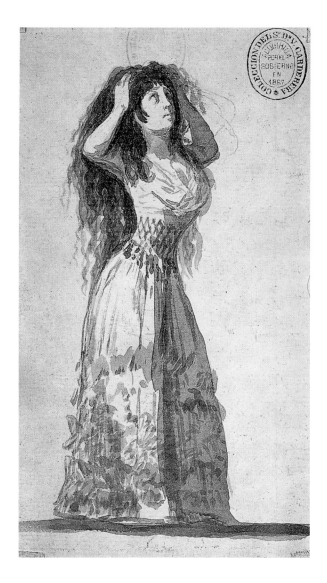

*Young Woman
Arranging Her Hair*,
1796–97
(Sanlúcar Album),
india ink wash,
6 ³/₄ × 4 in.
(17.1 × 10.1 cm),
Paris,
private collection

friend Arali mentioned in his letter. The thought suggests itself
that Goya visited the dying duke, whom he had just portrayed the
previous year, and, as his drawing would imply, encountered the
Duchess of Alba at her husband's bedside.

The Duchess of Alba appears to feel unobserved as she tenderly holds little María de la Luz in her arms, unobserved as, with her head thrown back, she rumples her hair with an expressive gesture. The young woman preparing to do her hair likewise seems unbothered by any intruder, as does another young woman who, lying in bed, is being cared for by an elderly lady. Such private everyday scenes are the subject of the sixteen drawings from Goya's hand, which are now generally

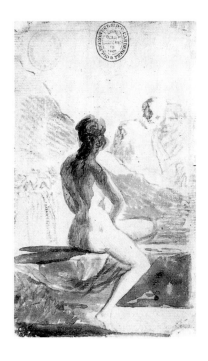

known as the Sanlúcar Album. The portfolio also includes five copies of lost originals, probably made by Valentín Carderera, Goya's first biographer. Twenty-one depictions, done with a brush on both sides of small-format sketching sheets, represent the sole surviving proof of the legendary encounter between Goya and the Duchess of Alba at her estate in Sanlúcar de Barrameda. They are like a diary, recounting not in words but in the language of painting those occurrences and observations that moved their author. But when would Goya have had the opportunity to see María Teresa Cayetana and the other young ladies in such an intimate setting?

"Francisco's happiness was complete. When he had arrived the day before late in the afternoon, she had run out to greet him, had shown her joy in a most unladylike way and embraced him in the presence of the major-domo. And

Young Woman Bathing at a Fountain, 1796–97 (Sanlúcar Album), india ink wash, 6 ³/₄ × 4 in. (17.1 × 10.1 cm), Madrid, Biblioteca Nacional

then while he was bathing and changing she had talked to him through the open door.... The days that followed were like the first, relaxed and happy. Much of the time he and Cayetana were alone," Feuchtwanger describes Goya's arrival at the palace of Sanlúcar.[24] Whether or not the reception was truly as romantic as this, we naturally cannot say. Moreover, it is improbable that the Duchess of Alba actually spent this time alone at Sanlúcar. Yet quite apart from those present at the duchess's palace during those summer days, Goya was certainly

among the welcome guests there, since, as his drawings reveal, he was permitted a glimpse into the private affairs of the house. But was he the duchess's lover, as Feuchtwanger goes on to relate? Whatever the case may have been, the two nude young women seated back to back, the young lady resting on a bed, or the unnamed beauty washing herself at a fountain, all attest to a carefree and intimate atmosphere during those days at Sanlúcar.

The question has frequently been asked whether a love tie between Goya and the Duchess of Alba could have been possible at all, in view of the differences of station that separated them. Manners and customs were strict, and the Spanish nobility in particular had for centuries placed great store in etiquette. However, during the reign of María Luisa in the late eighteenth century, different moral values applied, above all at court, as an English traveler suggested in his report on the arrival of the royal court in Aranjuez.

The court was scheduled to arrive on January 6, this observer wrote, and with it came the usual amusements. Masses of players and harlots of every age, from every class, of every sort were there; absolute liberty in morals and demeanor reigned.[25] Not even the Queen of Spain scrupled to make her love affair with a young cadet public, by naming him Duke of La Alcudia, and eventually even making him an infante of Spain by arranging his

Francesco Battaglioli,
Aranjuez Palace,
1756,
oil on canvas,
26 ³/₄ × 44 in.
(68 × 112 cm),
Madrid,
Museo del Prado

marriage with a Spanish princess. The Duchess of Alba, too, free of class prejudice in any case, could certainly have let herself in for a love affair with the court artist without infringing on etiquette. In this regard, their contemporaries judged, the two ladies were more than a match for each other. In view of the lax morals at the Spanish court, what seems troubling is not so much the fact of a love affair as the point in time at which it is traditionally said to have taken place — namely, a few weeks after the death of the Duke of Alba.

However, yet another, different point in time for an intimate meeting presents itself. María Teresa Cayetana, after the official funeral ceremonies in the capital on September 4 and 5, 1796, returned to Andalusia to spend the mourning period at Sanlúcar. This we know from a priest by the name of Aria de Arjona, who penned a sonnet with the dedication: "For a lady who, just widowed, went to Sanlúcar de Barrameda to mourn."[26] Unfortunately the clergyman neglected to date his poem. So we do not know exactly when the duchess and her entourage set off for Andalusia.

On February 16, 1797, at any rate, the Duchess of Alba signed her last will and testament in Sanlúcar. Goya remained in Andalusia. His presence in Madrid is not recorded until the beginning of April 1797, when he requested in writing that the Royal Academy release him from his duties as head of the painting class, owing to his complete deafness. The academy received Goya's letter on April 4.[27] In other words, the legendary encounter between Goya and the Duchess of Alba in Sanlúcar de Barrameda could also have taken place some time between the middle of September 1796 and the end of March 1797. Neither letters nor other documents exist to indicate where Goya spent those fall and winter months. Only in the duchess's final will do we find an indirect hint at a period spent together with the artist.

Javier Goya,
1805–06,
oil on copper,
3 ¼ in. (8.1 cm) in diam.,
Paris, private collection

The Last Will and Testament

On February 16, 1797, the Duchess of Alba wrote her last will and testament in Sanlúcar de Barrameda. It was probably neither illness nor dire premonitions that moved her to do so, but concern for the property and future of the House of Alba, whose administration, after her husband's death, now lay solely in her hands. The wording of the will gives us insight into how the young widow must have thought and felt as she was writing it, far from the capital, in the retirement of rural Sanlúcar: "I appoint as heirs in equal part of my entire fortune," the document begins, "which from now on belongs or will belong to me, Don Carlos Pignatelli, D. Ramón Cabrera, D. Jayme Bonells, D. Francisco Durán, D. Tomás de Berganza, D. Antonio Bargas, and D.ᴬ Catalina Barajas."[28] These are no dukes, counts or relatives whom María Teresa Cayetana chose to inherit her unimaginable riches, but merely persons with whom she was familiar, whom she trusted, admired, and loved. First place is held by her stepbrother Carlos, the youngest son of the Count of Fuentes, a close friend since her childhood. Also named are the two physicians Bonells and Durán, the former the Alba family doctor, the latter court physician to the royal family. The administrator of the Alba estates, Tomás Berganza, is also appointed a chief beneficiary. Berganza paid last respects to the duke and subsequently accompanied the duchess to Sanlúcar. Then, at seventh place, follows the name of María Teresa's chambermaid, Catalina Barajas, about whom very little is known. She was likely one of the duchess's closest confidantes, both prior to and during her period of mourning in Andalusia. But as if this were not enough of a good thing, the duchess goes on to mention by name in her will all the children and needy persons in her circle: María de la Luz, her little black foster daughter, whose appearance Goya recorded for posterity in the Sanlúcar Album; Luisito de Berganza, her administrator's son, who is seen in the small painting of 1795; the three children of her maid Catalina, the four children of the two physicians, and the eldest son of Antonio Bargas; the maids who accompanied her on the journey to Andalusia, as well as those who had always faithfully served her; Benito, the Albas' dwarf court jes-

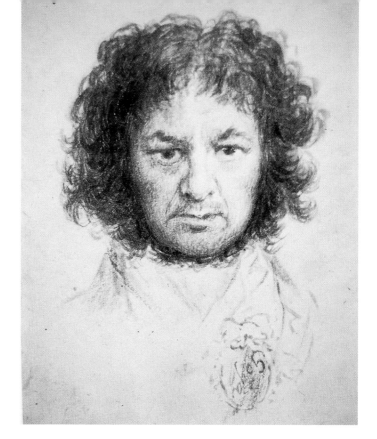

ter; Pepito, a foundling who always came to the house for meals; Trinidad, the nurse of little María de la Luz; and, finally, a list of the poorer among the duchess's vassals. Everyone who had meant something to María Teresa Cayetana and for whom she felt responsible during her lifetime was to have a secure existence after her death. The final place on her list was reserved for the son of "D. Francisco Goya," who was to be paid an allowance of "10 reales" a day until the end of his life. We do not know whether the duchess had ever met Javier Goya, who was twelve at the time, or knew him only from his father's anecdotes. The mention of his name is possibly not only proof of María Teresa's love of children but of her affection for Goya. This passage in her will is the sole indication of an emotional tie between the duchess and the painter. There is no letter, no note from her hand from which we might infer the feelings of María Teresa Cayetana, XIIIth Duchess of Alba, for Francisco Goya. He, in contrast, left us a painted confession of love.

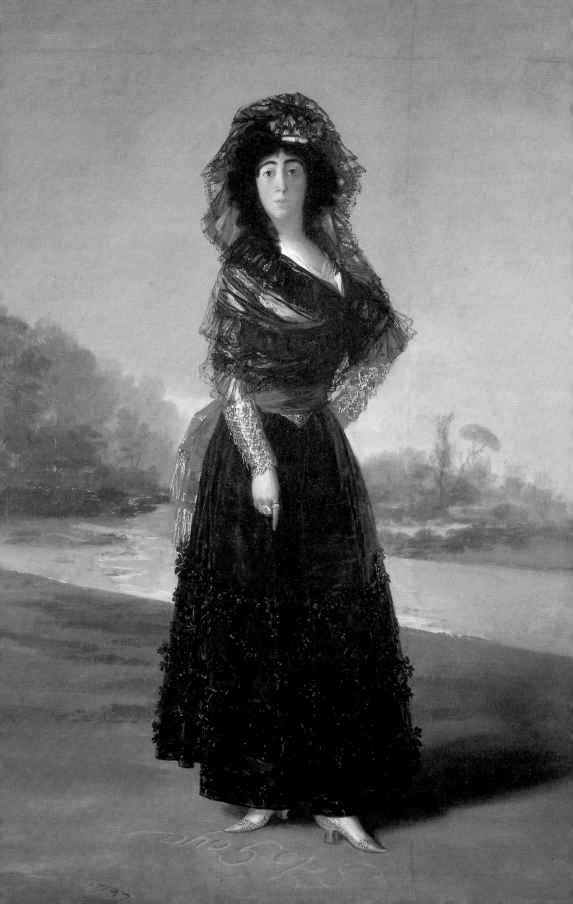

"Only Goya" –
The Portrait of the Duchess of Alba in Black

Head held high, the Duchess of Alba stands on the bank of a river in the midst of an unidentified but definitely Andalusian landscape. She gazes at us candidly and self-confidently, yet her gaze is no longer as cool and proud as in the *Portrait in White* Goya painted of her two years previously, in Madrid. Her large dark eyes under thick black brows appear sensual and melancholy. As befits a widow, she is clad in black, but her costume is suitable not only for a widow but for a *maja*, as signaled by the gold-colored blouse under the black veil, the red sash, and the gold brocade shoes. Also revealing is the black fleck on the duchess's right temple. This is a beauty spot, which tells the initiated what moves its wearer: passion. As if challengingly, the duchess rests her left hand at her waist and points brusquely downwards with her right. Nothing, except the color black, seems to recall the suffering and mourning of the months just past. Another revealing detail are the two rings on her right hand: the large, oval one on her middle finger bears the name "Alba," and the narrower one on her index finger the name "Goya." Written in the sand at her feet in large letters are two words, "Solo Goya" (Only Goya), at which her extended index finger almost commandingly points. Yet the inscription is upside down from the beholder's point of view, as if intended for the duchess's eyes only. Who did Goya mean to say these words, which so openly declare the exclusiveness of their love? Was it María Teresa who scratched the words into the Andalusian sand? Or Goya himself?

The painting was done in the year 1797, according to the date at the lower left edge, which, unlike the inscription, is oriented toward the viewer and thus clearly distinguished from the perceptual level of the love message. Goya painted the *Portrait of the Duchess of Alba in Black* either during the first three months of the year 1797 in Andalusia, or he began it there some time between January and March,

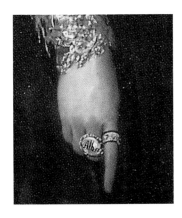

Portrait of the Duchess of Alba in Black, 1797, oil on canvas, 82 ³/₄ × 58 ¹/₄ in. (210.2 × 149.3 cm), New York, Hispanic Society of America

intending to finish it in his Madrid studio upon his return in early April. Did María Teresa Cayetana commission Goya to depict her in *maja* costume during her mourning period in Andalusia? Who suggested including those revealing details in the composition, especially the ring with the name "Goya" engraved on it? In view of the compromising message of the picture, one tends to think the duchess may not even have seen the final version. Would a widow whose husband had not been dead for a year have herself portrayed with another man's name on her ring, turning the portrait into an open confession of love? Perhaps Goya merely began the picture in the final few days spent with the duchess in Andalusia, and completed it later, in the quiet and retirement of his Madrid studio. Very likely it was only here that he added the accessories, which so clearly record the love between him and María Teresa. At any rate, the portrait remained in Goya's possession until 1812. In the inventory prepared by his wife after his death, it is listed as "Portrait of the Alba," under number "14." One might assume that, after its completion, the portrait never left the artist's studio. Or perhaps it was returned to him after the love affair with the duchess was definitely over? Such questions have remained open to this day, and, unless further sources are discovered, they will probably never be conclusively answered.

Yet proof of a love affair between Goya and the Duchess of Alba does seem to have been found, in the 1950s, when the word "Solo" came to light in the course of a restoration of the painting. As pigment analysis showed, the retouching dated to the same period as the portrait's execution. This means that Goya himself, or a contemporary, must have subsequently painted over the revealing word "Only." Perhaps Goya decided to retract his painted avowal of love shortly after the portrait was finished; perhaps he intuitively no longer trusted his love of the woman who had cast her spell over him for a few months of his life. Yet no matter the reason for the deletion of the word "Solo," the two rings on María Teresa Cayetana's fingers speak for themselves. They unite the names "Alba" and "Goya" forever.

Closely linked with the romance between Goya and the Duchess of Alba are two paintings of his that are among the most renowned works of Spanish art: *The Naked Maja* (*La maja desnuda*) and *The Clothed Maja* (*La maja vestida*). In the former a young woman, entirely nude, reclines on a bed covered with silk draperies. Her hands clasped behind her head, she looks straight out at us. Her open, direct gaze underscores the nakedness of the body she so matter-of-factly presents. Who is this young lady who shows herself so calmly, self-confidently, and provocatively to the viewer? Her counterpart, *The Clothed Maja*, plays with female charms in no less voluptuous a way. She lies in the same pose, only dressed; yet the thin cloth of her white gown traces only too faithfully the contours of her body. Her gaze, like her entire appearance, is defiant and expectant. Who is she? And who would dare commission such a work at a time when the depiction of female nudity in Spanish art was conceivable only under the veil of mythology, embodied in a Venus or a Diana?

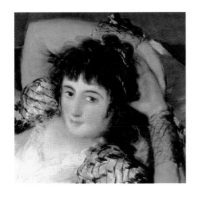

The Clothed Maja,
ca. 1798–1805,
detail of illus.
on pages 54-55

But Goya's *maja* is no goddess. She is a woman of flesh and blood, if one whose identity has remained uncertain to this day, as has that of the person who ordered the two very similar paintings.

The fame of the two *Majas* is rivaled by the obscurity of their history. It was not until 1800 that it began to be documented, albeit fragmentarily. The earliest mention of *The Naked Maja* in the sources dates to that year, when, on November 12, the medallion-maker González Sepúlveda visited Godoy's painting collection in Madrid.[29] According to Sepúlveda, "the nude woman by Goya" hung together with depictions of Venus in a small chamber. *The Clothed Maja* was not mentioned by this early witness. It crops up in the sources for the first time in January 1808, and likewise in the Godoy collection, which was inventoried shortly before Godoy's political fall in March by the French painter Frédéric Quilliet, who believed the young woman represented must have been a gypsy, because no one

else, he maintained, would have allowed herself to be depicted in the nude. The next news concerning the two *Majas* dates to November 1814, when, with three other "obscene" paintings (the term used in the files), they were turned over to the judges of the Inquisition. In this case the authorities no longer saw a gypsy in the figure, but "a naked woman" or "a woman dressed as a *maja*" (the earliest application of this designation to the model). In Catholic Spain, the incident naturally had consequences. In March 1815, shortly before his sixty-ninth birthday, Goya was summoned to appear before the Inquisition tribunal, to explain "whether these pictures were from his hand, on what occasion he painted them, on whose orders, and with what intent."[30] Unfortunately we do not know the results of the interrogation. The only secure reply we can give today to the interrogators' queries is that Goya indeed painted the two *Majas*. But who gave him the commission? And who modeled for him?

Goya's *Naked Maja* was in the possession of Godoy from 1800 onwards. Some authors therefore assume that he commissioned it. The model for the painting could have been Pepita Tudó, Godoy's longtime mistress, who bore him several children and whom he later married, after the death of his wife, the Countess of Chinchón. No authenticated portrait of Pepita Tudó that might confirm this assumption has been discovered. We do have a delightful portrait of Godoy's young wife, painted by Goya in 1800–01, which in no way resembles the nude *maja*. Yet quite apart from whether it was Pepita Tudó or an anonymous nude model who put herself at Goya's service, argue the advocates of this hypothesis, only Godoy had the power to commission such a painting in Spain without incurring the wrath of the Inquisition. To this, one can only reply that late eighteenth-century Spain naturally had many other influential men and women

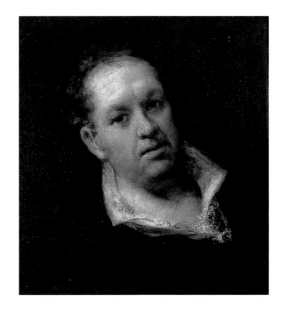

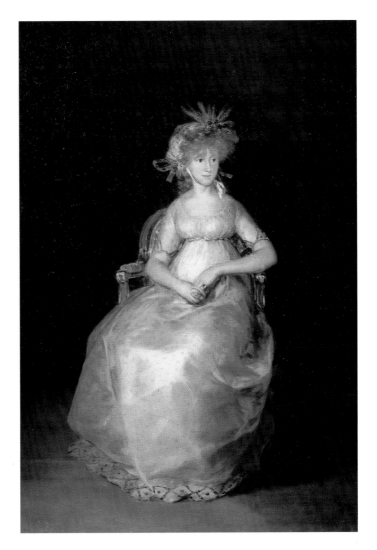

Countess of Chinchón,
1800,
oil on canvas,
68 ⁵/₈ × 56 ³/₄ in.
(174.2 × 144 cm),
Madrid,
private collection

Self-Portrait at the Age of Sixty-Nine, 1815,
oil on panel,
20 × 18 ¹/₈ in.
(51 × 46 cm),
Madrid,
Real Academia de Bellas Artes de San Fernando

besides Godoy who could and would have taken such a risk. For instance the Duchess of Alba, who, as we know, was only too ready to challenge conventions. But what could have prompted María Teresa Cayetana to commission *The Naked Maja* from Goya?

Goya painted *The Naked Maja* before 1800. Stylistic analysis has led most historians to date it between 1795 and 1800. These years in Goya's life were shaped by his encounter, or encounters, with the Duchess of Alba. Before 1797 he had executed

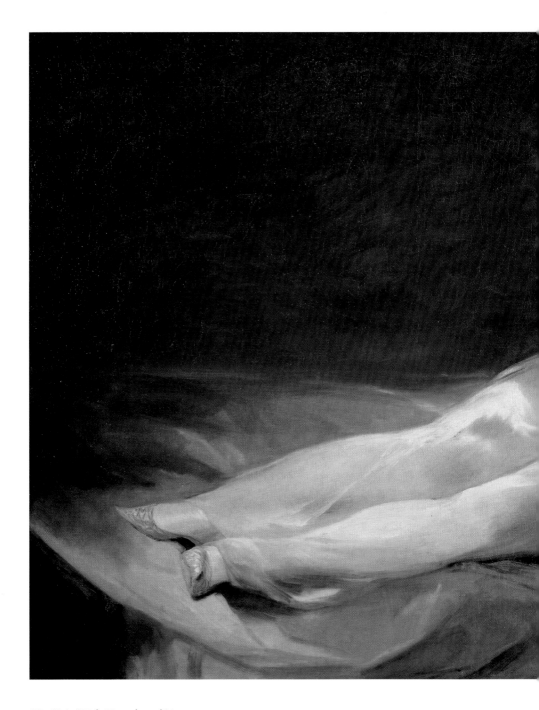

The Clothed Maja (*La maja vestida*), ca. 1798–1805,
oil on canvas, 37 3/8 × 74 3/4 in. (95 × 190 cm),
Madrid, Museo del Prado

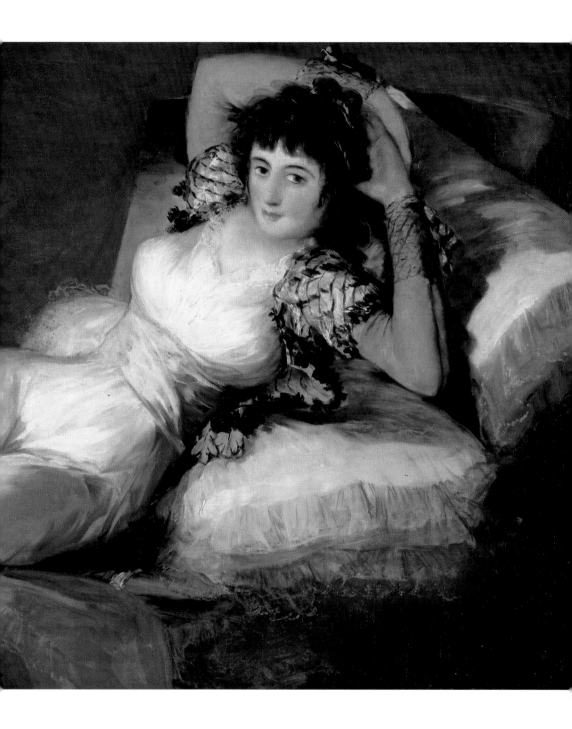

her *Portrait in White*, the little scene with "La Beata," the Sanlúcar Album, and the duchess's *Portrait in Black*. During this period Goya certainly had access to the large gallery of paintings owned by the Albas, which then as now included world-famous works. Here he would have seen the renowned Venus by Velázquez, known as the *Rokeby Venus*, done in 1650 and now in the National Gallery, London. It depicts a nude young woman reclining on a bed with her back to the viewer, her head propped on her right arm. Only the little Cupid to her left indicates that it is Venus who is looking at herself in the mirror. With this painting, Velázquez created one of the most exciting nude female backs in art history. Goya, too, was evidently fascinated by it, as a drawing from the so-called Madrid Album proves. It shows a nude young woman from the back who, like Velázquez's Venus, contemplates herself in a mirror. Might it not

be that Goya was testing his powers here against those of Velázquez, whose work he had copied early on and whom, at the end of his life, he called one of his masters? Paragons of this kind are not seldom in art history. Velázquez, for his part, had once measured himself against Titian. Conceivably the Duchess of Alba even challenged the established Court Painter Goya to a posthumous competition with the great Velázquez, by asking him to paint a Venus of his own for her. Whatever the case, Goya did not recur to Velázquez's time-tested composition. He tried something different, and went a momentous step further in the process: he stripped the mythological veil from the female nude and depicted, simply, an unclothed mortal woman. With his *Naked Maja* Goya created a work that was revolutionary for the era and above all for Spain, and every bit a match for Velázquez's. But let us return to the question of Goya's model.

Young Woman Raising Her Skirt, 1796 (Sanlúcar Album), india ink wash, 7 $^{1}/_{2}$ × 3 $^{7}/_{8}$ in. (19 × 9.7 cm), Madrid, Biblioteca Nacional

 As early as the middle of the last century a few authors began to surmise that it was the Duchess of Alba who modeled for Goya. Baudelaire, too, who knew the painting only from reproductions, saw the noble Alba in the lovely lady. What could have induced Baudelaire and many other authors to think of her in connection with *The Naked Maja*, despite the lack of similarity? Was it perhaps the young woman's sensuality,

The Duchess of Alba (?), 1796–97
(Sanlúcar Album),
india ink wash,
6 ³/₄ × 3 ⁷/₈ in. (17 × 9.7 cm),
Madrid, Biblioteca Nacional

Nude Women on a Bed,
1796–97 (Sanlúcar Album),
india ink wash,
6 ³/₄ × 4 in. (17.2 × 10.1 cm),
whereabouts unknown

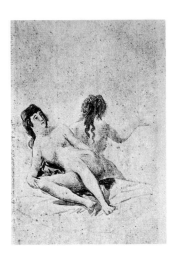

which the duchess's contemporaries said she possessed in great measure?

The drawings in the Sanlúcar Album, done during the days Goya spent near the duchess in Andalusia, are likewise suffused with covert eroticism. A closer look even reveals certain similarities, which suggest that during his time at Sanlúcar Goya was already toying, consciously or unconsciously, with the thought of painting a *maja* of this kind. Take, for instance, the two nude girls on the bed, one seen from the front and the other from behind. Frontal nude and back nude: the same dualistic principle as in Goya's *Naked Maja* and Velázquez's *Venus*, or in the *Naked* and *Clothed Maja*. This same duality is also found in a drawing whose obverse shows a young woman in a long dress, who is generally thought to represent the Duchess of Alba. Turning the sheet over, one sees a young lady with her skirt hiked up, saucily extending her behind toward the viewer. Goya was able to enjoy such small intimate scenes as an observer in a relaxed, carefree atmosphere, far from the mundanity of Madrid life. He saw María Teresa ruffling her hair, the young woman at the fountain, the two girls on a bed. All of these impressions, it is safe to say, probably excited and inspired the fifty-year-old, deaf painter no less than did Velázquez's *Venus*. In Sanlúcar, then, Goya might well have conceived the idea for his *Naked Maja*, who presents her nakedness as frankly and freely as the girls in the album. It is also thinkable that one of the women from the duchess's entourage sat to Goya for that picture. Yet there is one striking difference: Goya's *Naked Maja* has none of the childlike, innocent air of the girls in the Sanlúcar Album. Her gaze is seductive, frank, and self-assured, just as one imagines that of fashionable women in late eighteenth-century Spain to have been. Nor are her eyes demurely lowered, as society still expected of women in the early years of the century. Moreover, the *maja* shows her feet — another privilege for which

The Naked Maja (*La maja desnuda*),
ca. 1798–1800, oil on canvas, 38 ¹/₄ × 74 ³/₄ in. (97 × 190 cm),
Madrid, Museo del Prado

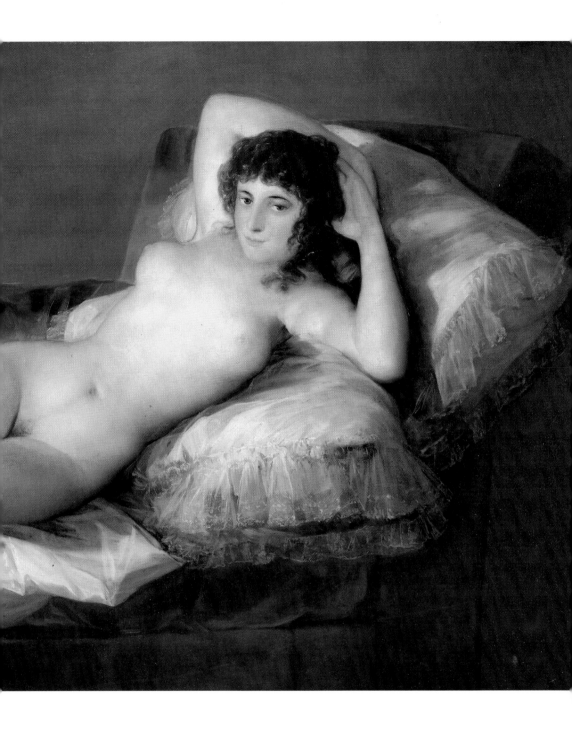

59

women had had to fight bitterly. In the seventeenth century, fashion had still dictated the wearing of a "tontillo," an inconvenient, hooped petticoat worn over the underclothes, the main purpose of which was to keep a woman's feet and legs concealed when she sat down. The French emissary Blécourt reported in 1702 that there were husbands who would rather have seen their wives dead before they exposed their feet.[31] But the fashion clock could not be turned back. Ladies showed their feet, which, clad in delicate shoes, soon became a prime focus of erotic appeal. The Duchess of Alba, reports a contemporary, wore a new pair of shoes every day.[32]

Goya's *Maja*, too, knew how to display her feminine charms playfully and self-assuredly to best effect. She was a "coqueta," a coquette, as that Spanish woman of the time was called "who by and large enjoys winning over the hearts of all without losing hers to anyone."[33] The notion of love as a game determined the relations between the sexes. The game was played with pleasure and according to fixed rules, above all by the ladies of high society, with the Duchess of Alba leading the way.

No matter who she may actually have been, Goya's *Maja* is an erotic symbol of modern womanhood in Spain at the end of the eighteenth century. She is nude model and Venus, portrait and metaphor in one. In this sense, at least, the *Maja* can justifiably be called a portrait of the Duchess of Alba, who stimulated masculine fantasies like no other woman of the day. Not even the clergy remained unaffected by her magnetism. For the priest Aria de Arjona of Seville, María Teresa Cayetana embodied "the new Venus" of Spain.

Who posed for Goya in the nude on the settee remains an unanswered question. At all events, as X-ray examination of the face and upper body has revealed, the face of *The Naked Maja* evinces a paint layer much thinner than that of the hair and neck, suggesting that the facial features may have been scraped off and repainted, perhaps to obscure the revelatory likeness to the living model for ever.

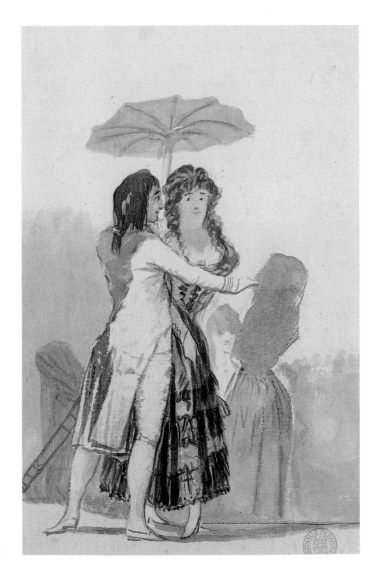

Couple with a Parasol,
1797 (Madrid Album),
india ink wash,
8 ³/₄ × 5 ³/₈ in.
(22.1 × 13.5 cm),
Hamburger Kunsthalle

The Beggar Woman,
1796-97
(Madrid Album),
india ink wash,
9 ¹/₄ × 5 ³/₄ in.
(23.4 × 14.5 cm),
Madrid,
Biblioteca Nacional

And what do we know about *The Clothed Maja*? Owing to the looser brushwork and a different palette, this version is generally dated later, usually between 1800 and 1805, that is, up to ten years after *The Naked Maja*. As we know, Sepúlveda, the medallion-maker, saw *The Naked Maja* in 1800 in Godoy's collection, but he made no mention of *The Clothed Maja* in his notes. Conceivably Godoy subsequently commissioned the latter canvas from Goya with an eye to heightening the erotic effect of the

former, by a sort of before-and-after juxtaposition. According to an anecdote dating to the late nineteenth century, the two paintings were once connected by a mechanism with the aid of which the clothed version could be made to vanish by pressing a button, revealing the nude version to view.

Even if Godoy actually did commission *The Clothed Maja*, this would by no means prove he ordered *The Naked Maja* as well. According to Sepúlveda, the renowned Venus by Velázquez, which he saw in November 1800 with Goya's *Naked Maja*

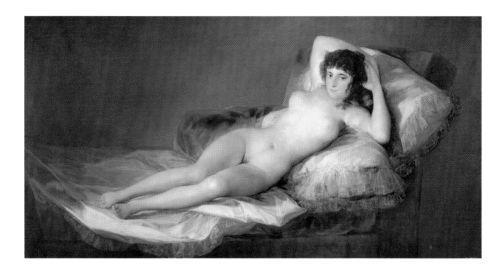

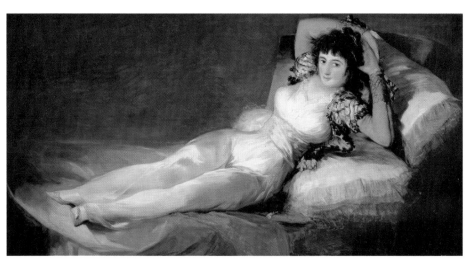

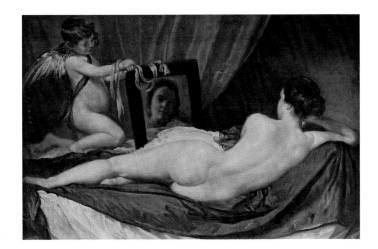

Diego de Velázquez,
Rokeby Venus, ca. 1650,
oil on canvas,
48 $\frac{1}{4}$ × 69 $\frac{5}{8}$ in.
(122.7 × 177 cm),
London,
National Gallery

in Godoy's little chamber, was a gift from the Duchess of Alba. Presumably it was a sign of her love for Godoy, with whom she had had an affair sometime between 1797 and 1800. The Spanish queen reacted with considerable jealousy to this romance of her *cortejo*. In a letter to Godoy written in 1800 she maliciously remarked about her rival, the duchess: "She looks wretched and emaciated; I don't believe this would happen to you again and I believe that you regret it terribly."[34] Godoy, for his part, seems to have felt deeply injured in his masculine pride by the duchess. In a letter to the queen of September 9 of the same year, he declared: "I am returning the Alba's letter to her, may she and all her hangers-on be buried in Hell, basta."[35] The affair between the Duchess of Alba and Godoy was apparently over by about 1800. She probably gave Velázquez's Venus to him before this date. But might she not have given Godoy other presents as well? *The Naked Maja* may have similarly changed hands, after the duchess had begun to feel her memories of the days she had spent with Goya at Sanlúcar belonged irrevocably to the past.

The Naked Maja and
The Clothed Maja

Dream of Lies and Inconstancy – The Disappointment

The carefree mood of those days at Sanlúcar was very likely soon dispelled when Goya returned to Madrid. Still under the impression of his experiences in sunny Andalusia, he sketched with rapid brushstrokes the first sheets of what is known as the Madrid Album (approx. 200 drawings), which, as the name indicates, was done largely in Madrid. If these initial drawings still recorded the lively antics of *majas* and *majos*, flirting and quarreling lovers, old

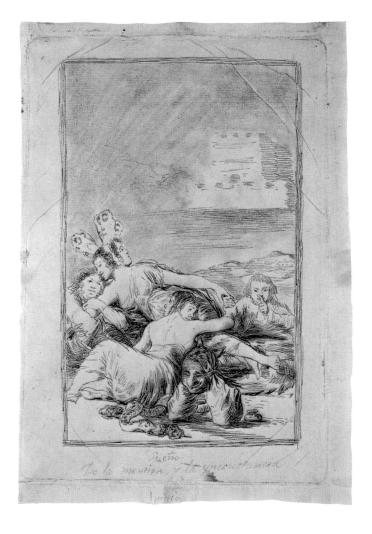

Dream of Lies and Inconstancy (Sueño de la mentira y la inconstancia), 1797–98, pen, sepia and ink wash, 9 ³/₈ × 6 ¹/₂ in. (23.7 × 16.6 cm), Madrid, Museo del Prado

ladies arranging matches and young girls dancing, the following sheets began to show a different, strange, and dark world. Humans with donkey's heads, witches and demons appeared, accompanied by sarcastic and mocking comments on the part of their creator. These were premonitions of that irrational realm which, after 1796, would increasingly suffuse Goya's oeuvre. Might it not have been deep passion and disappointed love that triggered this change?

That something must have occurred between 1797 and 1798 in the relationship between Goya and the Duchess of Alba may be inferred from an etching and its preliminary drawing, *Dream of Lies and Inconstancy* (*Sueño de la mentira y la inconstancia*),

Hypocrisy, from Cesare Ripa's *Iconologia*

that Goya did at that time for the *Caprichos*. Here, we are confronted with a two-faced woman with butterfly's wings hovering in the air over an expansive landscape. This is the Duchess of Alba. To her right kneels Goya, passionately embracing her arm. But the second face of his beloved is turned away from him and her gaze directed into the distance, where a male figure appears in the gloom. The man's gesture tells us something mysterious is happening here. He knows more than the main protagonists and intends to make us privy to his secret. Another woman with two faces places the stranger's hand in that of the duchess. This is her servant, as her submissive look indicates. Yet her twofacedness reveals this figure to be an allegory of hypocrisy or deceit, as already depicted by Cesare Ripa in his *Iconologia*. She is evidently spinning the intrigue of an incipient triangular relationship, of which Goya, in his mistress's arms, is still unaware. But he is tormented by a bitter premonition, as we may gather from the title of the print. Seen in this light, the snake and the frog in the foreground can be interpreted as symbols of lasciviousness and lust, and the duchess's butterfly wings as symbols of frivolity and thoughtlessness. The mask is an attribute of deceit, and the saddlebag on which it rests can

be linked with the Spanish proverb "changing to another saddle-bag" ("pasarse a la otra alforja"), which in this context probably means taking the liberty of choosing a new lover.[36] The male figure approaching the couple out of the darkness seems to be this new lover, awaiting his opportunity to encourage dissention and jealously between the two. Possibly Goya even had in mind a certain admirer who might threaten his love for the Duchess of Alba. Perhaps he was thinking of Godoy, whose affair with her began some time after 1797.

Dream of Lies and Inconstancy eloquently attests to Goya's bitter insight that the exclusive affection that he had still attributed to the duchess in his 1797 portrait was an illusion. His reason for not including the etching as planned in the *Caprichos* may well have lain in the directness of its statement, which was too personal for public eyes. Besides the preliminary drawing, only one impression of the etching is known to exist.

Francisco de Goya y Lucientes, Painter,
No. 1 of the *Caprichos,*
1797–98,
etching, aquatint,
drypoint and burin,
8 ⅝ × 6 in.
(22 × 15.3 cm)

They Have Flown –
Memory in the *Caprichos*

On February 6, 1799, the daily *Diario de Madrid* carried a frontpage announcement of the publication of the *Caprichos*: "A collection of prints on whimsical subjects, invented and etched by Don Francisco Goya," it began. "The author," it continued, "convinced that the censure of human errors and vices can be as much the subject of painting as it is of oratory and poetry, has chosen for his work themes from the multitude of follies and wrong-doings, which are common to all societies, of prejudices and lies countenanced by custom, ignorance, or self-interest, which he has considered appropriate to submit to ridicule, in order to exercise his fancy." [37]

In writing the advertisement for the *Caprichos*, Goya was presumably aided by the poet Leandro Fernández de Moratín (1760–1828) and the art critic Ceán Bermúdez, with whom he resumed close ties on his return from Andalusia. As the first sentences make clear, the *Caprichos* with their total of eighty prints represented an audacious, socially critical satire on Spanish society of the period, with all its weaknesses, "extravagances and follies." Nor did the Duchess of Alba escape Goya's scathing eye. In No. 61 of the series she is pictured flying heavenwards with outstretched arms, supported by three cowering figures. The black skirt with its wasp waist, the blouse tied over the breast, and the black mantilla recall the *Portrait in Black* Goya painted of the duchess in 1797. Her head, however, is no longer adorned with a graceful comb but with a butterfly with outspread wings, similar to that in *Dream of Lies and Inconstancy*. What Goya intended to express in this image may be gathered in part from the appended commentary (known as the Prado commentary), which, it is now generally assumed, he wrote himself: "The group of witches who serve the lady as underpinning, are more decoration than necessity. There are heads so full of inflammable gas that they need neither balloons nor witches to make them fly." Goya avoids all direct reference here. "The lady" is merely characterized as light-headed and highly explosive, perhaps in allusion to her personality and temperament, and the three figures at her feet are called witches,

Volaverunt.

They Have Flown
(*Volaverunt*),
No. 61 of the
Caprichos, 1797–98,
etching, aquatint
and drypoint,
8 ⅝ × 6 in.
(21.9 × 15.2 cm)

but superfluous appendages. In contrast, there are two, unfortunately anonymous, commentators from within Goya's orbit who expressed themselves in less uncertain terms. In the so-called Ayala commentary, named for its former owners, the Ayala family, we read: "The Duchess of Alba. Three toreros are turning her head." Similar wording is found in a third commentary on this etching, which is now in the Biblioteca Nacional in Madrid: "Three toreros are turning the Duchess of Alba's head, such that ultimately on account of her capriciousness she loses her mind." The duchess's penchant for bullfighting — and for

bullfighters — was common knowledge. The three figures accompanying the duchess on her flight are therefore often seen as caricatures of three toreros, who were famous at the time. Yet when we look more closely at the leftmost of the three figures, who is missing from the preliminary drawing to the etching, his broad nose, thick lips, and protruding lower jaw recall the self-portrait Goya drew on the letter he wrote to his friend Zapater, telling him of the duchess's visit to his studio.

Detail of Goya's letter to Martín Zapater on page 19

Goya published the etching under the Latin title *Volaverunt* (*They Have Flown*), which figuratively means something like "over and done with." This verdict can really only refer to his relationship with the Duchess of Alba, which had already been destroyed by "lies and inconstancy." If this is so, in his *Caprichos* Goya wished not only to publicly confess his love for the flighty duchess, as in *Dream of Lies and Inconstancy*, but also to publicly state that the relationship had come to a conclusion. If one interprets the third figure at the duchess's feet as a self-portrait, Goya had already achieved a certain self-ironical detachment from the affair. His romance was a thing of the past.

The female figure flying away is the sole confirmed depiction of the Duchess of Alba in the *Caprichos*. But when one leafs through the prints, one has the impression of seeing the illustrious lady rather frequently. It is the recurring figure of a slender young woman with tiny waist and long dark hair who immediately calls the duchess to mind. Yet already in the Sanlúcar drawings, where the graceful creature first appeared in Goya's work, her identity blurs. Is the *maja* in a black mantilla the Duchess of Alba, a lady of her *cortège*, or a girl from the streets? Evidently the young duchess's appearance, her slender waist, and flowing hair, had already begun to shape Goya's image of femininity back then.

As early as the drawings of the Madrid Album, these graceful females had already begun to show that more troublesome side that would figure so strongly in the *Caprichos*. One finds them in the role of the innocent beauty being courted by a beau, the coquettish temptress fully aware of her erotic charms, or the *maja* with an old matchmaker at her side. Taken in sum, Goya's

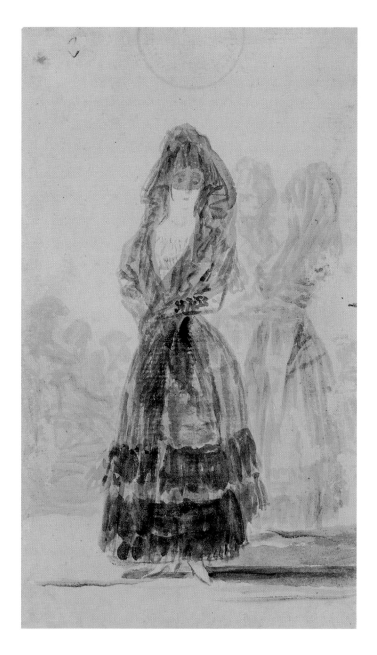

*Maja on the
Promenade*, 1796–97
(Sanlúcar Album),
india ink wash,
4 ⅛ × 3 ½ in.
(10.6 × 8.9 cm),
Madrid,
Museo del Prado

depictions amounted to an ironical and critical compendium of the images of women held by a society that, by the end of the eighteenth century, had started to fall apart at the seams. And the Duchess of Alba was the one woman of the period

who appeared to embody all of these images: a lovely *maja*, as in Goya's portrait of 1797; a tempting *femme fatale*, as her contemporaries saw her; and a woman open to the blandishments of love, as she appeared in *Dream of Lies and Inconstancy*. Goya had the opportunity to acquaint himself with this wide range of feminine temperaments, and with all the joys and sorrows they could cause — united in a single woman. But he also had the strength to detach his experiences from his own personal suffering, to supplant them with sarcasm and irony, to use them as the source of his artistic creation. This is why we have the feeling of so often encountering the Duchess of Alba in the *Caprichos*.

There is another print in the *Caprichos* whose composition may well have been influenced by Goya's recent passion. No. 19 shows a birdlike creature with a woman's head, being approached by birdmen flying through the air. As soon as a male succumbs to infatuation for her, he crashes to the ground, where he is gleefully plucked by two seated women under the supervision of an old matchmaker. Here the male is depicted not only as a victim of feminine seduction but as a victim of his own sexual instincts, as the torments inflicted on him by the two young women make clear. Yet the title of the etching, *All Will Fall* (*Todos caerán*), also seems to refer to the birdwoman, who is perched high in the crown of a tree, balancing on a wheel. Was this perhaps a sarcastic jab on the part of a disappointed yet self-critical Goya at the Duchess of Alba, haughtily flying away from him yet destined, like everyone else, to fall?

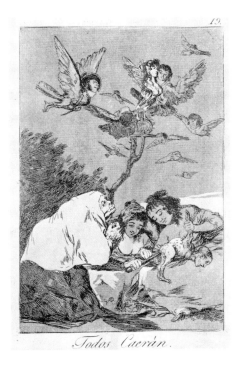

All Will Fall (*Tòdos caerán*), No. 19 of the *Caprichos*, 1797–98, etching and burnished aquatint, 8 $^5/_8$ × 5 $^3/_4$ in. (21.9 × 14.6 cm)

On July 24, 1802, the *Gazeta de Madrid* carried the following no-
tice: "The many and commendable aptitudes that distinguished
Her Excellency, above all the gentleness and kindness of her
nature, her noble generosity and the charity with which she fer-
vently empathized with every woe as soon as it came to her ears
— she sheltered widows, cared for the sick, instructed helpless
children, supported honest orphans on their life's path, and distri-
buted without abate great sums to her servants, who loved her
like their mother — have caused her death to be felt very painfully
by all."[38] Thus read the obituary of the Duchess of Alba, who had
died the previous day. Though the news may have come as a sur-
prise to the public on that July morning, people close to the
duchess knew very well what the state of her health had been in
the foregoing weeks.

On June 30, the Countess of Montijo had written to the poet
Meléndez Valdés, "The poor Duchess of Alba … is on the verge
of dying. On Saturday afternoon she had an attack, from which
she recovered yesterday, and there was reason for hope, but today
she is worse than yesterday. Robbed of her senses and con-
sciousness, she has not yet been able to receive the sacraments."[39]
The countess's daughter, Tomasita Palafox, Marchioness of Vil-
lafranca and the Duchess of Alba's sister-in-law, had watched by
the bed of the dying woman. On July 7, the countess reported in
another letter, her state seemed to improve, "but she has recover-
ed neither the use of her senses nor her consciousness."[40] Only
baths were able to alleviate the tremors that racked her body.
After five weeks of agony, María Teresa Cayetana de Silva, XIIIth
Duchess of Alba, died just short of her fortieth birthday, in
her house on Calle del Barquillo. On the death certificate, issued
on July 25, the duchess's family doctor, Jaime Bonells, wrote:
"I certify that Her Excellency, María Teresa de Silva, Duchess
of Alba, died of a colic yesterday noon, at 12:40 p.m."[41] The fu-
neral was held in private, as she had desired in her will, at the
church of the Convent of the Padres de Salvador, on the evening
of July 26.

Hardly had the news of the duchess's death become known in
Madrid when numerous rumors began to spread. She had been

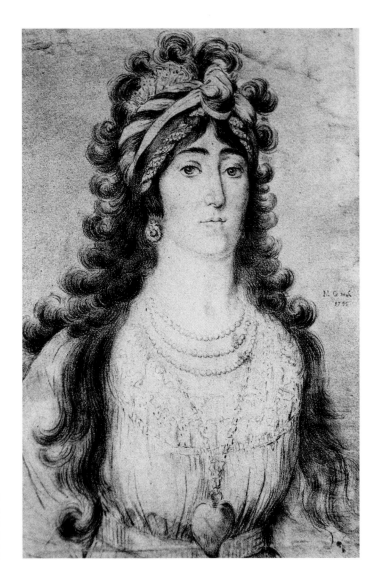

Mariano González
de Sepúlveda,
The Duchess of Alba,
1795,
pencil,
private collection

poisoned, the common people believed, and the perpetrators should be looked for in the circles around the queen and her favorite, Godoy. At court, on the contrary, it was put about that the duchess's servants had caused her sudden death, since their mistress had so richly provided for them in her will.

In order to quash such rumors, Charles IV, in a letter of July 30, entrusted his prime minister, Manuel Godoy, with the investigation of the case.[42] In this letter he also expressed his

distrust of those persons who were with María Teresa Cayetana during her illness and at the hour of her death. He was especially suspicious of her servants. Unfortunately no document has come to light concerning the results of this investigation, which ultimately would only have brought the intrigues at court to public attention. Yet Charles IV and María Luisa did not only show interest in elucidating the circumstances surrounding the duchess's death but also in her estate, especially her pearls and diamonds. Not two days had passed after her death when the royal couple informed the executor, José Navarro Vidal, that they wished to view the jewelry of the deceased. On July 29 the selected pieces were evaluated, and by August 1 a considerable portion of the Alba jewels were already in the possession of the queen, who had bought them at the "official estimate." María Luisa was able to adorn herself with her rival's jewels sooner than she had probably anticipated. Godoy, too, was not short-changed. Buenavista Palace was put at his disposal by the city of Madrid. The opening of the will finally took place on August 6. Since the Duke and Duchess of Alba remained childless, the title passed to the grandson of their great aunt, who was just eight years old at the time. Their fortunes and properties were divided among the seven chief heirs named in the will. Yet the distribution of the estate was still not finished after thirty years, when Carlos Pignatelli, son of the Count of Fuentes and the Duchess of Alba's stepbrother, died in Paris on November 24, 1832.

The rumor concerning the duchess's unnatural death remained alive into our own century. Those obsessed by the myth not surprisingly included one of her own descendants. On November 17, 1945, the then Duke of Alba had the remains of María Teresa Cayetana exhumed. The autopsy indicated that the XIIIth Duchess of Alba had died a natural death. The cause of death, according to the three investigating physicians, was encephalitis, which had been preceded by a lymph infection that had damaged the kidneys and lungs. No traces of poison were found.[43] Lion Feuchtwanger did not believe in a dastardly plot, either. In a more "romantic" version, which sealed the fateful character of her love affair with Goya, the author envisioned her dying after an unsuccessful abortion. The father of the child: Goya.

The medical triumvirate made another, rather eerie discovery during the autopsy. Both feet were missing from the body.

They had been cleanly severed at the height of the tarsus. The right foot lay in the coffin; of the left there was no trace. A search for the reason for this strange mutilation led the physicians back to the year 1843, when, owing to conversion work on the Padres del Salvador Church, the mortal remains of the Duchess of Alba had to be disinterred and taken to San Isidoro Cemetery. A new coffin was ordered to transport the body. According to the results of the 1945 autopsy, however, the coffin was exactly 3½ in. too short. Instead of ordering another, the officials apparently chose the easier and quicker solution, likely believing no one would ever discover the belated amputation. No member of the Alba family was present. In the hurry and confusion, the autopsy doctors presumed, they had simply forgotten to put the left foot in the coffin. Yet mightn't this missing part of such a famous and notorious lady's anatomy have some other explanation, involving superstition and reliquary veneration?

Though no one in nineteenth-century Spain likely still believed in witches, devils and demons, a tendency to mysticism had by no means disappeared from a country where the Inquisition continued to stir popular anxieties with public heresy trials well into the century. Though the Duchess of Alba was certainly not a witch, she was a woman surrounded by legend even during her lifetime, a woman who was not only loved but envied and hated. In view of this, and in view of the exaggerated reliquary cult among the Spanish people, her missing foot may well have an explanation beyond human error. Cause for further speculation were the physical measurements of the body, determined at the autopsy. The duchess's height of 5 ft. 4 in. and the proportions of her slender figure, said the three doctors, evinced a certain similarity to Goya's *Naked Maja*. After thorough analysis, they planned to publish the results of their investigations in a book, which was even announced in 1949 by the Duke of Alba himself.[44] However, the report never appeared.

THE DESIGN FOR HER TOMB:
GOYA'S FAREWELL

The years between 1797 and 1802 were not only years of dis-appointment for Goya. On returning to Madrid he commenced work on the *Caprichos*. Though their publication did not prove the public success for which he had hoped, his original new etchings were acclaimed by his friends. Some of Goya's admir-ers, such as the Duchess of Osuna, even bought several copies of the series. A connoisseur and lover of Goya's art, the duchess had been intrigued from the start by the unfamiliar, hallucinatory imagery she saw emerging under his hand. While he was still involved in preparatory work on the *Caprichos*, she ordered six paintings depicting scenes with witches, for her country house, La Alameda. Charles IV and María Luisa, too, lost no time in putting their returned court artist to work. In the spring of 1798 the king commissioned Goya to paint frescoes in the recently completed the Church of San Antonio de la Florida. A direct commission from the court meant that he had a free hand in artistic matters. His designs for the decoration of the church had to be submitted neither to the Cathedral Chapter nor to the Royal Academy of Fine Arts. This was truly a stroke of luck, because with the San Antonio de la Florida frescoes Goya raised a memorial of a very special kind to himself, as if he

Michel Ange Houasse,
*View of the Monastery
of El Escorial*,
ca. 1730,
oil on canvas,
19 ⁵/₈ × 32 ¹/₄ in.
(50 × 82 cm),
Madrid,
Museo del Prado

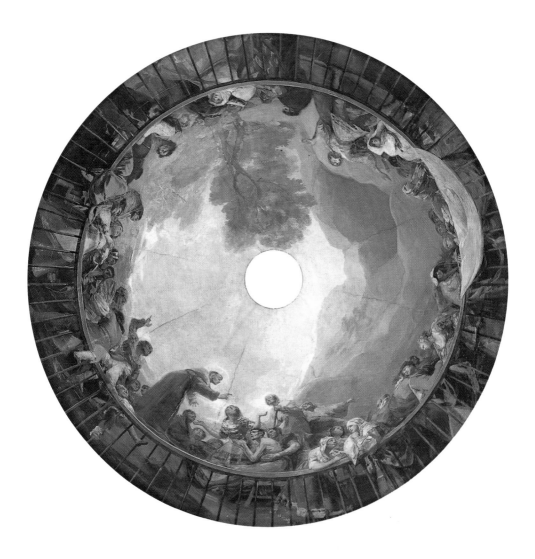

*The Miracle of St.
Anthony of Padua*,
1798,
fresco, approx. 18 ft.
(5.5 m) in diam.,
Madrid,
San Antonio de la Florida

had had a presentiment that the church would one day be his last resting place.

In September 1799 Goya traveled to La Granja, the summer residence of the court, near Segovia. The late Baroque palace in the French style had been erected by Philip V in 1721. Here, in addition to the *Portrait of the King as a Hunter*, Goya painted his *Portrait of the Queen as a Maja*, in a black mantilla. The first lady of Spain, then forty-eight, is shown self-confidently posing in the costume of the people, as if to challenge her rival, the Duchess of Alba. Presumably María Luisa knew from hearsay of

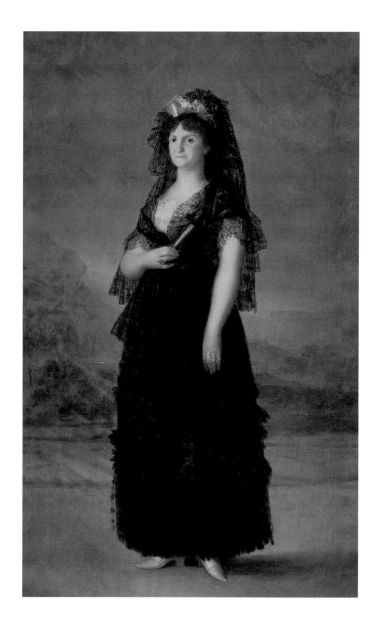

Portrait of the Queen as a Maja, 1799, oil on canvas, 82 ⁵/₈ × 51 ¹/₈ in. (210 × 130 cm), Madrid, Palacio Real

the *Portrait of the Duchess in Black*, because the amorous affairs of her Court Painter would not have escaped the watchful eye of the ever-jealous queen. In October of that same year, 1799, Goya joined the court at the Escorial, where it regularly spent several months of the year. The ecclesiastical and royal residence outside Madrid had been erected under Philip II, in the

Family of Charles IV, 1800–01, oil on canvas, 110 × 132 ¹/₄ in. (280 × 336 cm), Madrid, Museo del Prado

latter half of the sixteenth century. Here Goya portrayed the royal couple on horseback, María Luisa mounted on her favorite steed, Marcial, a present from her protégé, Godoy. The portraits apparently pleased the king and queen, because before the month was out Goya was named First Court Painter. Finally, in the spring of 1800 he commenced what would turn out to be the most important royal commission of all: a portrait of the family of Charles IV. In Aranjuez, where the court resided every year from Easter to July, Goya spent late May to early June making portrait sketches of the key members of the royal family. Over the following months, based on these sketches, Goya created in the quiet of his studio the renowned *Family of Charles IV*, in which, cognizant that he was at the peak of his fame, Goya included a portrait of himself.

Whether Goya saw the Duchess of Alba again at court, or at one of the grand aristocratic festivities, remains an open question.

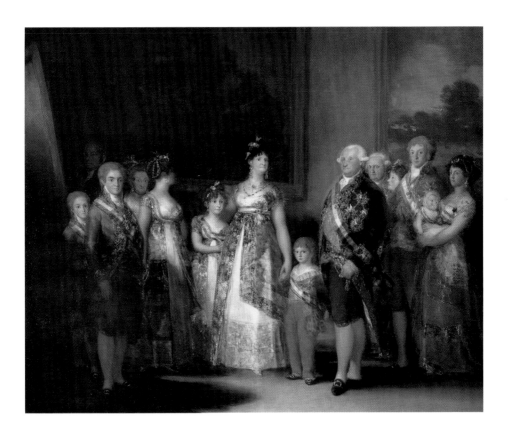

Design for the
Duchess of Alba's
tomb,
after a sketch by
Goya,
Madrid, Collection of
Berganza de Martín

However, their paths may well have crossed once more at Aranjuez. Thanks to the brisk correspondence between María Luisa and her lover, Godoy, we know that the Duchess of Alba was with the queen on the afternoon of April 24, 1800, in the company of her friend, Rafaela Solano. The two planned to stay in

Aranjuez for six days.[45] At the time Goya was probably still occupied with his *Countess of Chinchón*, Godoy's young wife, but the removal of his studio from Madrid to Aranjuez was in the offing. Yet even if Goya and the duchess had accidentally met during those days in Madrid or Aranjuez, she would no longer have had eyes for him. The reason was an army general by the name of Antonio Cornel y Ferraz, whom both Godoy and the queen, as we know from their letters, hated from the bottom of their hearts. The duchess had a love affair with him, if Godoy's remarks in a letter to María Luisa of September 9 can be believed. An observation of the queen's, dated April 30, that the Duchess of Alba "was as crazy as in the first days of her youth," would also speak for the existence of a love affair.[46] Except for a possible fleeting encounter, no tie remained between Goya and the Duchess of Alba. Nor, after 1797, are any further commissions to Goya from the House of Alba recorded.

The sole evidence that Goya took note of the duchess's death consists in a small ink drawing. It shows three figures in long cowls, their faces concealed, tenderly laying out the body of a woman before the open door of a pyramid. It is the body of the Duchess of Alba. Goya depicted his friend in death with the same charm and tenderness he devoted to her in the early drawings done at Sanlúcar. Nothing remains of the haughty demeanor of the woman who flew from him in the *Caprichos*.

Tántalo.

With the composition of this interment scene in mind, however, there is another etching in the series, No. 9, that recalls the Duchess of Alba. It bears the title *Tantalus*. In ancient Greek mythology, Tantalus was a son of Zeus who rashly challenged the omniscience of the gods. He was punished for this by eternal torment — hunger and thirst without end. Fruit dangling over his head vanished as soon as

Tantalus reached for it, and the lake in which he stood withdrew as soon as he tried to drink. Goya's Tantalus suffers as well, in this case the torments of love, as indicated by the Prado commentary on this etching, whose wording is probably Goya's own: "If he were a better lover and less boring, she would revive again." The cause of his suffering is evidently the woman in Tantalus's lap. She has fainted; her head and arm dangle limply. Tantalus, his hands folded, gazes imploringly towards heaven. Is Goya evoking the torments of a passionate but unrequited love from his own experience? The Ayala commentary, also contemporaneous, would seem to confirm this assumption: "If he were more attractive and young, he would arouse her. This is what happens to old men who marry young women" – and to those who fall in love with them as well? When the etching was completed Goya was fifty-two years old and deaf, and the duchess thirty-six, beautiful, and desired by many. Might the suffering Tantalus stand for the aging Goya, who was quite aware of his awkward situation? The idea of a link between Goya and Tantalus, as between the unconscious woman and the duchess, seems all the more convincing when the etching is compared with the artist's vision of the duchess's tomb. It repeats not only the diagonal of the reclining female figure but the pyramid in the background, which in emblematic tradition of the day was interpreted as a "sign of dependence on the loved one."[47] Yet the memory of former torments seems to have been expunged in the face of the loved one's death.

Perhaps Goya was asked by her heirs to prepare a design for the duchess's tomb. In any case, the drawing is now in the possession of the Berganza family, who at the time were among the duchess's chief heirs. Another open question is whether the composition was intended for the crypt or for the church of the Padres Misioneros del Salvador, or whether it was ever executed. Today the church is part of the auditorium of Madrid University. When conversion work began in 1842, the duchess's remains were taken to San Isidoro Cemetery. Here they lie in a marble pantheon, beneath a bust of the unforgettable Duchess of Alba.

BIOGRAPHICAL NOTES

María Teresa Cayetana de Silva, XIIIth Duchess of Alba

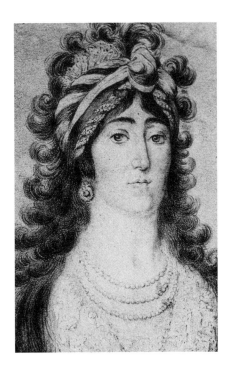

Mariano González de Sepúlveda, *The Duchess of Alba*, 1795, detail of illus. on page 73

On June 10, 1762 María Teresa Cayetana de Silva is born in Madrid to Don Francisco de Paula de Silva y Alvarez de Toledo y Portugal (b. 1733), Duke of Huéscar and heir to the name of Alba, and the young Doña María del Pilar Ana de Silva y Sarmiento de Sotomayor (b. 1739), who have been married for almost five years. The infant Duchess of Alba is christened the next day at Santos Justo y Pastor Church, with a total of thirty one Christian names in honor of the family's ancestors and patron saints: María del Pilar, Teresa, Cayetana, Manuela, Margarita, Leonor, Sebastiana, Bárbara, Ana, Joaquina, Josefa, Francisca de Paula, Javiera, Francisca de Asís, Francisca de Sales, Andrea, Abelina, Sinforosa, Benita, Bernarda, Petronila de Alcántara, Dominga, Micaela, Rafaela, Gabriela, Venancia, Antonia, Fernanda, Bibiana, Vicenta, and Catalina.

María Teresa Cayetana and her parents live in the palace of her paternal grandfather, Don Fernando de Silva de Toledo, XIIth Duke of Alba, in Piedrahita, near Avila, in central Spain. The countless rooms of the two-story palace (which would be destroyed in the wars that ravaged Spain in the early nineteenth century) all have wall coverings, some of silk and damask. Above the doors are paintings *à la chinoise*, the fashion throughout Europe at this time. The girl's grandfather resides in opulent chambers on the second floor. On the ground floor is a large library, which, apart from tractates on military history, is devoted largely to works by contemporary authors. In this luxurious residence in the country, overlooking the wide valley of the Río Corneja owned by the Dukes of Alba, María Teresa Cayetana spends her early childhood.

1768

In July her father, Don Francisco – against his will and that of his family – is promoted to lieutenant general. The provisions made by the Duke of Alba for his future widow and their potential descendants on the occasion of his son's marriage and over the following years, suggest that the state of Don Francisco's health has not been good. He has a reputation for love affairs and inveterate gambling.

1769

In September the Duke of Alba purchases Buenavista, a mansion located on Calle de Alcalá in Madrid, followed in December by four additional buildings nearby. The young family moves in to No. 1, Calle del Barquillo; No. 5 is reserved for the grandfather.

1770

Shortly after the move from Piedrahita to Madrid, on April 26, Don Francisco, Duke of Huéscar, only son of the XIIth Duke of Alba, dies at the age of thirty-seven in his new house on Calle del Barquillo. In a letter dated May 14, the Count of Villahermosa writes to his friend: "The Duke of Huéscar has died within a few days, with a great deal of money and a great many doctors...."[48] His seven-year-old daughter, María Teresa Cayetana, is now the sole future heir of the House of Alba.

1773

On October 11 a marriage contract is concluded between the eleven-year-old María Teresa Cayetana and the seventeen-year-old José (b. 1756), later Marquess of Villafranca. The document is signed by the groom's parents and the bride's grandfather, by his sister, the Duchess of Medina-Sidonia, and by the bride's mother, widow of the Duke of Huéscar.

1775

On January 15, a grand double marriage is held in Madrid: María Teresa weds Don José, who came into the title of Marquess of Villafranca after his father's death; and María Teresa's mother, Dowager-Duchess of Huéscar, weds the considerably older Count of Fuentes, Don Joaquín Pignatelli de Aragon. He is

the father of her young lover, who died only a few months before. The reason for her sudden marriage is unclear. María Teresa and Don José move in to her parents' mansion on Calle del Barquillo.

1776

The family's newfound happiness is short-lived. After only a year of marriage, the Count of Fuentes dies on May 14. He leaves three sons from a previous marriage to his young wife, now widowed for the second time. The youngest, Carlos, who is very attached to María Teresa, remains with his stepmother. The same year, on November 15, María Teresa's grandfather, the Duke of Alba, dies at the age of sixty-two. The young woman inherits a great fortune and the name of Alba, which she will bear from now on as the XIIIth Duchess of Alba. Her spouse, Don José, Marquess of Villafranca, assumes the title of Duke of Alba as stipulated in the marriage contract.

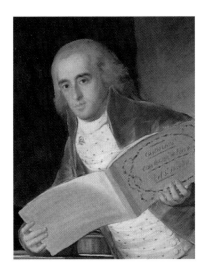

The Duke of Alba,
1795,
detail of illus.
on page 31

1777–1778

Charles III soon makes the new duke valet to the Prince of Asturias, later Charles IV. During the Christmas holidays — probably with an eye to the imminent marriage of María Teresa's mother with the Duke of Arcos (January 1, 1778) — a great festivity is held in the Alba house. It includes a performance of a little farce by Ramón de la Cruz, in which the young Duchess of Alba plays the leading role of Laura. In September the duke and duchess travel together to Andalusia for the first time. These years witness the beginnings of extensive conversion and new construction work on Buenavista, which transform it into a stately townhouse (now the headquarters of the Spanish Ministry of Defense) of the kind already envisioned by the duchess's grandfather.

1780

On December 13, the Duke of Arcos, her mother's third husband, dies. From now on her mother lives in retirement in

Moncloa Palace, on the outskirts of Madrid. The following years of the Duchess of Alba's life are only sparingly documented.

1784

María Teresa's mother, widow of the Duke of Arcos, dies on January 17, just forty-three years of age. She leaves her entire estate, including Moncloa Palace, to her daughter.

1792

The Duchess of Alba spends the months of September and October alone at her country estate in Piedrahita near Avila, where, according to the sources, she recovers from a serious illness. In November she returns to the capital to meet her husband at the royal residence, El Escorial, outside Madrid. In early December she returns alone to Madrid.

1793–1794

The Duke of Alba travels in September to La Granja, the former summer residence of Philip V, near Segovia, where the court foregathers every year at this time. In November he rejoins the duchess at the Escorial. The duchess returns to Madrid earlier than her husband, as she did the previous year.

1795

The Duke and Duchess of Alba spend the year in Madrid. In November and December Don José accompanies the court alone to the Escorial. This year sees Goya paint his full-length portraits of the Duke and Duchess of Alba.

1796–1797

Death of the Duke of Alba at the age of thirty-nine, on June 9, 1796, in Seville. The duchess spends several weeks together with Goya at Sanlúcar de Barrameda. The following year Goya paints the *Portrait of the Duchess of Alba in Black*.

1798

According to the diaries of Pepita Tudó, the Duchess of Alba has an affair with Manuel Godoy in the years after her husband's death. Godoy is not only the queen's favorite, and lover, but also Pepita Tudó's long-time lover and later husband.

1800

Love affair with General Antonio Cornel y Ferraz.

1802

According to a letter of the Countess of Montijo, dated August 9, the Duchess of Alba marries for a second time. Her second husband's name is not recorded. The Countess of Montijo describes him as "a good man, with a sad existence, which only religion and philosophy ... sustained."[49] On April 3 the Duchess of Alba borrows 5,480,000 reales (in comparison, Goya earned 50,000 reales a year as Court Painter) from two distinguished persons at court. She agrees to pay the money back in two installments, on September 1 and December 1 of the same year. The promise is never kept.

Death of the Duchess of Alba, on July 23. The funeral takes place on the evening of July 26, in the church of the Padres Misioneros del Salvador. The name of Alba passes to Carlos Miguel F. J. Stuart y Silva (1794–1835), a distant relative who is eight years old. Nearly forty years of quarreling ensue over the duchess's estate.

1842

The church having fallen into disrepair, the remains of María Teresa Cayetana, XIIIth Duchess of Alba, and the Duke of Arcos are removed to Sacramental de San Pedro Cemetery, also known as San Isidoro.

Exhumation of the remains of the Duchess of Alba in 1945

1945
Exhumation of and autopsy on the remains, at the behest of the then Duke of Alba.

The biography of the Duchess of Alba largely rests on what is still the standard work on her life, Joaquín Ezquerra del Bayo's *La Duquesa de Alba y Goya.*

1746

Francisco de Goya y Lucientes is born on March 30 in Fuendetodos, a small town near Saragossa in Aragon, northeastern Spain. His father, José Goya, is a master gilder; his mother, Engracia Lucientes, comes from an impoverished noble Aragonese family.

1760

Little is known about Goya's childhood. He is probably taught at the Escuelas Pías in Saragossa. At age fourteen he enters the studio of the painter José Luzán Martínez in the same city.

1763–1764

Goya travels to Madrid, whose art scene has been dominated since 1761–62 by Anton Raffael Mengs (1728–79) and by the Venetian Giovanni Battista Tiepolo (1696–1770) and his two sons. Goya submits work to the competition held every three years by the Royal Academy of Fine Arts. However, the jury does not give the young artist's entry a single vote (January 1764). Whether he returns to Saragossa after this disappointment is not recorded.

1766

Goya again tries his luck at obtaining a scholarship to the Royal Academy of Fine Arts, but his endeavors are once again unsuccessful.

1770–1771

Goya travels to Rome in 1770 and takes part in a competition held by the Academy of Parma in 1771 with a history painting that earns him at least six jury votes and an honorable mention. He introduces himself as a pupil of the painter Francisco Bayeu (1734–95) of Saragossa, who, with his brother Ramón, was called to Madrid in 1763 at the behest of Mengs and, in 1765, named Court Painter. Bayeu is a zealous representative of the academic neoclassicism advocated by Mengs.

1771–1772

In late June 1771 Goya returns to Saragossa. On October 21 of the same year he receives his first important commission, to paint a fresco in the vaulting of the small choir ("coreto") of El Pilar Cathedral in Saragossa, which is completed in June 1772. The fresco, a Baroque composition in the manner of Tiepolo, is highly acclaimed by Goya's patrons. He probably learned the fresco technique in Italy.

1773

On July 25 Goya marries Josefa Bayeu, twenty-six, the sister of his teacher Francisco Bayeu. There is no known extant portrait of Josefa in her younger years.

1774

Goya and his wife move to Madrid, where they initially reside at his brother-in-law's home at Calle del Reloj, No. 7–9. During this period Goya executes paintings for the Charterhouse Aula Dei, near Saragossa. Later that year Goya is appointed Court Painter by Mengs, at the behest of Bayeu.

1775

This year witnesses the beginning of Goya's activity for the Royal Tapestry Manufactory, Santa Bárbara, in Madrid. There emerge the first cartoons for Gobelins in the academic style of Bayeu. Devoted to the theme of the hunt, the Gobelins are intended for the banquet hall of the Prince of Asturias, later Charles IV, and his wife María Luisa of Parma, in the Escorial. The Goyas' first child is born on December 15, in the Bayeu home (no further details are recorded).

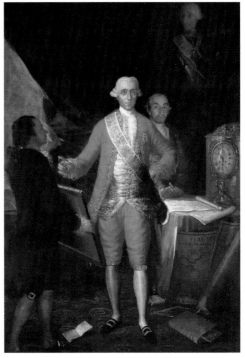

1776–1778

Goya receives a commission for a second series of ten cartoons depicting

popular entertainments and diversions, for the banquet hall of the Prince and Princess of Asturias' hunting seat, El Pardo, outside Madrid. The artist and his wife live at Carrera de San Jerónimo, No. 66.

1778–1780

In 1778 Goya publishes etchings after paintings by Diego Velázquez (1599–1660) in the royal collection, which Mengs recommended young artists to study. Here Goya already employs the recently invented aquatint technique, the handling of which he would develop to absolute mastery in the coming years. Charles III commissions a third series of tapestry designs from Goya. Completed in January 1780, the series is intended for the decoration of the Prince of Asturias' chambers in El Pardo.

1780

Goya is elected member of the Royal Academy of Fine Arts. His admission piece is the *Christ on the Cross*, painted in the academic manner, for San Francisco el Grande in Madrid (it now hangs in the Prado Museum). At the end of the year he receives a

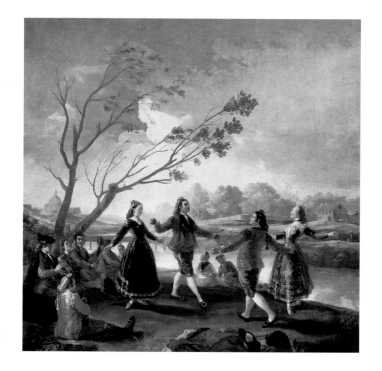

Study for *The Dance on the Banks of the Manzanares River* (*La baille a orillas del río Manzanares*), 1777, chalk, 11 ³/₈ × 8 ⁷/₈ in. (28.9 × 22.5 cm), Madrid, Museo del Prado

fresco commission for El Pilar Cathedral, Saragossa, but is compelled to work under the supervision of Bayeu, who was entrusted with decorating the church in 1776. Goya's designs for the vaults, owing to their free, loose paint handling, draw sharp criticism from his brother-in-law and the ecclesiastical building authorities, who maintain they are not "finished." This sketchiness would become a characteristic feature of Goya's style. The fresco designs mark his first public revolt against the dominant neoclassical taste represented by Bayeu. As yet, however, his revolt is in vain. Goya is forced to conform to his patron's wishes regarding the execution of the frescoes.

1781–1783

Death of the artist's father in 1781. The same year Goya begins the large-format painting of St. Bernardine (approx. 16 × 10 ft.) for the church of San Francisco el Grande in Madrid, on which he works for two years. In 1783 he executes *The Count of Floridablanca*, First Secretary of State to Charles III. This is Goya's first official portrait, in which he feels confi-

Self-Portrait at the Age of Thirty-Seven, 1783, oil on canvas, 33 ⁷/₈ × 23 ⁵/₈ in. (86 × 60 cm), Agen, Musée des Beaux-Arts

dent enough to include a self-portrait, at the left edge. Presumably through the count's good graces, Goya is introduced that same year to the Infante, Don Luís, brother of Charles III. At Don Luís' country residence in Arenas de San Pedro (Avila) Goya paints numerous portraits of family members. These likely include the monumental portrait of Don Luís and his family, in which Goya once again commemorates his own features. In September he returns to Madrid.

1784

On December 2 Francisco Javier Goya (d. 1854) is born, the only child from the marriage with Josefa who is recorded to have survived. The family lives — probably since 1779 — at Calle del Desengaño, No. 1.

1785

On March 18 Goya is appointed Deputy Director of Painting at the Royal Academy of Fine Arts. Numerous works are executed for the Duke of Medinacelli and the Duke and Duchess of Osuna, one of the most prominent families in Spain, who would continue to supply Goya with regular commissions until 1799.

1786–1787

On July 25 Goya is appointed Painter to the King (Pintor del Rey) by Charles III, an honor that, according to a letter to his close friend, Zapater, he owes to Bayeu. To underscore his new social status he buys a carriage and begins to sign his works "Francisco de Goya." This year sees him paint a cycle of seasons for the Royal Tapestry Manufactory and eight murals in the same style for the Osunas' country house.

1788

Goya commences a sequence of tapestry cartoons for the infantas' bedroom, the execution of which is interrupted by the death of Charles III on December 14. Only the painting *Blindman's Buff* (*La gallina ciega*) is finished.

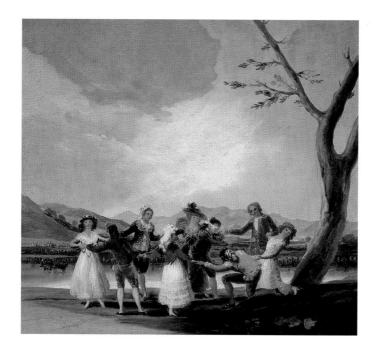

1789

The new king, Charles IV, and his wife, María Luisa, appoint
Goya Court Painter (Pintor de cámara). They order a number of
portraits of the royal family from him. This year also witnesses
the emergence of the family portrait of the Duke of Osuna with
his wife and children.

1791

Final designs for the Royal Tapestry Manufactory.

1792–1793

Goya's first journey to Andalusia. He contracts an illness in
October 1792 that would lead to his incurable deafness the
following year. He returns to Madrid and cancels fifty contracts
with the Royal Tapestry Manufactory.

1793–1794

The group of "cabinet paintings" and numerous portraits are
executed in 1793. The following year the Duchess of Alba visits
Goya in his studio.

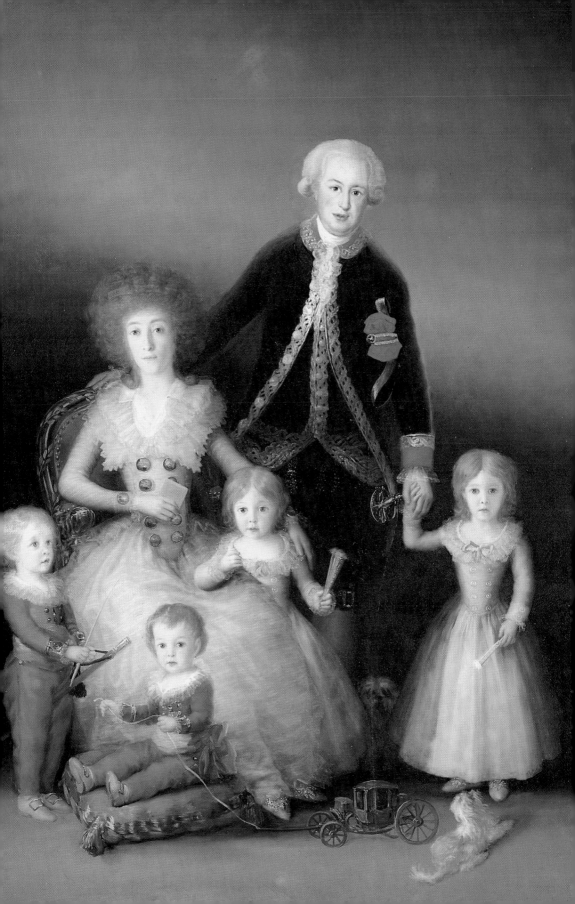

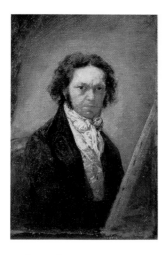

Self-Portrait, 1795–97, oil on canvas,
7 7/8 × 5 1/2 in. (20 × 14 cm),
Madrid, Collection Alejandro Pidal

Self-Portrait, ca. 1797–1800,
oil on canvas, 24 3/4 × 19 1/4 in.
(63 × 49 cm), Castres, Musée Goya

1795

Death of Goya's brother-in-law, Francisco Bayeu, whose portrait the artist has painted earlier that year. Goya becomes Director of Painting at the Royal Academy of Fine Arts. Before the year is out he receives his first commission from the House of Alba: the full-length portraits of the Duke of Alba and the Duchess of Alba in white. Two small-format oil sketches of his sitters are done concurrently.

1796–1797

Goya's second journey to Andalusia, and his sojourn with the Duchess of Alba at Sanlúcar de Barrameda. He executes several intimate drawings of the duchess, some motifs of which would be used in the *Caprichos* series. In 1797 he paints the *Portrait of the Duchess of Alba in Black*.

1797–1798

Goya concentrates largely on the preliminary drawings and etchings for the *Caprichos*. For La Alameda, the Osunas' country estate, he paints six pictures representing witches. In spring 1798 he is commissioned to paint frescoes in the Church of San Antonio de la Florida in Madrid, which is consecrated with great pomp in July of the following year.

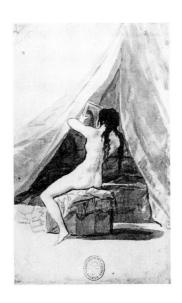

Nude Woman Looking in the Mirror,
1797 (Madrid Album),
india ink wash,
9 ³/₈ × 5 ³/₄ in. (23.7 × 14.5 cm),
Madrid, Biblioteca Nacional

Mariano Goya,
ca. 1815, oil on panel,
23 ¹/₄ × 18 ¹/₂ in. (59 × 47 cm),
Madrid,
Alburquerque Collection

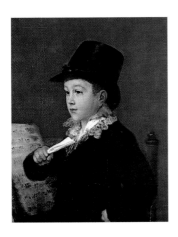

1799

On February 6 the publication of the *Caprichos* is announced in the *Diario de Madrid*. In September and October, while the court is at La Granja, Goya executes the *Portrait of the King as a Hunter, Portrait of the Queen as a Maja,* and *María Luisa on Horseback.* On October 31 Goya is named First Court Painter (Primer pintor de cámara).

1800–1801

In spring 1800 Goya follows the court to Aranjuez. The subsequent months witness the emergence of the famous group portrait *Family of Charles IV.* It is Goya's last official commission.

1802

Design for the sepulcher of the Duchess of Alba. From this year until 1808 Goya paints a number of portraits.

1803

Fearing indictment by the Inquisition, Goya turns over the copperplates of the *Caprichos* to the king.

1805–1806

In 1805 Goya's son Javier marries Gumersinda Goicoechea, the daughter of a prosperous Madrid merchant. The following year Goya's grandson, Mariano Goya y Goicoechea, is born.

1808

After the abdication of Charles IV on March 19 the Academy of Fine Arts commissions Goya to paint a portrait of his successor, Ferdinand VII. Yet the new king remains in office for only a few days, soon relinquishing his crown to Napoleon. On June 6 Napoleon's brother, Joseph Bonaparte, is proclaimed King of Spain. The bloodbath that takes place on May 2 and 3 in Madrid is commemorated by Goya six years later, in two monumental canvases, *Second*

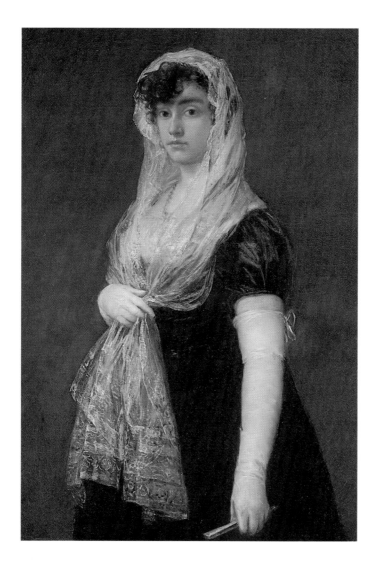

The Bookseller's Wife,
ca. 1805–08,
oil on canvas,
43 ¹/₄ × 30 ³/₄ in.
(109.9 × 78.2 cm),
Washington, DC,
National Gallery of Art

of May 1808 and *Third of May 1808.* These two days mark the beginning of the five-year Peninsular War, whose atrocities Goya records in his series *Disasters of War* (*Los desastres de la guerra*) and in many small-format paintings.

1810–1811

Beginning of work on the *Disasters,* a series of eighty etchings, the majority of which are probably done between 1812 and 1814, when Madrid is in the throes of a terrible famine. The etchings

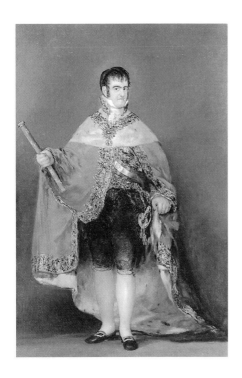

Ferdinand VII in a Royal Cape, ca. 1814,
oil on canvas, 83 ½ × 57 ½ in. (212 × 146 cm),
Madrid, Museo del Prado

Leocadia, 1819,
fresco for the Quinta del Sordo (Country House
of the Deaf Man), Madrid, Museo del Prado

are not published until after Goya's death. The first edition of *Disasters of War* appears in 1886, printed by the Academy of Fine Arts. In 1811 Goya receives a commission for the painting *Allegory of Madrid*, in honor of Joseph Bonaparte, who awards Goya a royal medal of honor the following year.

1812

Goya's wife Josefa dies on June 20. Their common property is inventoried and the estate divided between Goya and his son, who inherits his parents' house and all paintings.

1814–1815

On the occasion of the long-awaited return from exile of Ferdinand VII (who would unexpectedly institute an absolutistic regime), Goya receives government support in 1814 to paint two large-format oils, *Second of May, 1808* and *Third of May, 1808*, which are prominently displayed on a triumphal arch as the king marches into Madrid. On October 2, 1814, Goya's young companion, Leocadia Weiss, gives birth to a girl, who is christened María del Rosario Weiss (d. 1843). (Goya's paternity has not been definitely established.) In November the painting collection of Godoy, which includes *The Naked Maja* and *The Clothed Maja*, is inspected by the Holy Office. Owing to the "obscene" depiction Goya must appear before the judges of the Inquisition in 1815.

1816–1817

Publication of the *Tauromaquia*, a series of thirty-three etchings, which illustrates

the history of bullfighting. Execution of an altarpiece to Saints Rufina and Justa for Seville Cathedral.

1819

On February 27 Goya purchases a country house on the banks of the Manzanares outside Madrid, Quinta del Sordo (Country House of the Deaf Man), where he lives with Leocadia and their young daughter María del Rosario. In the winter Goya falls seriously ill. He is treated by his friend, Dr. Arrieta. Out of gratitude Goya paints a self-portrait after his recovery, showing himself, marked by suffering and pain, in the arms of his friend.

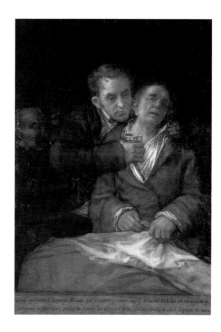

1820–1823

These years find Goya painting the *Black Paintings* (*Pinturas negras*) as decorations for Quinta del Sordo, and working on the etching series *Follies* (*Los disparates*), the printing of which, by the Academy of Fine Arts under the title *Proverbs* (*Los proverbios*), would be delayed until 1864. On September 17, 1823, Goya gives his country house to his grandson, Mariano.

Goya and His Doctor, Don Eugenio Garcia Arrieta, 1820, oil on canvas, 46 × 79 $\frac{3}{8}$ in. (117 × 79 cm), Minneapolis, MN, Institute of Arts

Self-Portrait at the Age of Seventy-Eight, 1824, pen and ink, 2 $\frac{3}{4}$ × 3 $\frac{1}{4}$ in. (7 × 8.1 cm), Madrid, Museo del Prado

1824

From January to April, Goya remains concealed for political reasons at the house of his friend José Duaso y Latre. On May 2, in order to ensure continued payment of his Court Painter's salary, he requests official leave to spend six months at a sanatorium in Plombières, France. In early July Goya leaves Spain and travels by way of Bordeaux to Paris, where he stays for two months, apparently with an eye to informing himself on the development of the new technique of lithography. In September he returns to Bordeaux, where he settles permanently with Leocadia and her two children (one a son from her first marriage). In the winter months Goya paints some forty miniatures on ivory, which he mentions in a letter to his friend

Joaquín Ferrer, maintaining that he has invented a new technique that is "closer to the art of Velázquez than to that of Mengs." From early on Goya considered Velázquez to be his true teacher.

1825

Involvement with lithography, resulting in a series of four prints titled *The Bulls of Bordeaux* (*Los toros de Buredos*).

1826–1827

In 1826 Goya travels to Madrid to petition Ferdinand IV to grant him retirement with continued salary, which the king does. (The reason for his earlier trip to the Spanish capital, in summer 1797, remains unclear.)

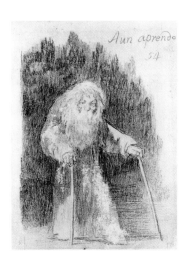

1828

On April 16 Goya dies in Bordeaux.

1901

Goya's remains are taken from Bordeaux to Madrid, where in 1919 they are finally interred in the Church of San Antonio de la Florida.

I Am Still Learning (*Aun aprendo*), 1824–26, black chalk, 7 $\frac{1}{2}$ × 5 $\frac{3}{4}$ in. (19.1 × 14.5 cm), Madrid, Museo del Prado

NOTES

1 Lion Feuchtwanger, *Goya oder Der arge Weg der Erkenntis*, 1st ed. 1951 (Weimar and Berlin, 1988). Quoted from the English translation, *This Is the Hour: A Novel about Goya*, trans. H. T. Lowe-Porter and Frances Fawcett (London, 1952), p. 226.

2 Joaquín Ezquerra del Bayo, *La Duquesa de Alba y Goya: Estudio biográfico y artístico*, 1st ed. 1928 (Madrid, 1959), pp. 66–67.

3 Ibid., pp. 105–07.

4 From *Voyage en Espagne*, 1796, quoted in Ezquerra del Bayo (note 2), p. 144.

5 Ezquerra del Bayo (note 2), p. 142.

6 Justo Garate, *El viaje español de Guillermo de Humboldt* (Buenos Aires, 1946), pp. 76–77.

7 Ezquerra del Bayo (note 2), pp. 125–31.

8 Earl of Ilchester (ed.), *The Spanish Journal of Lady Elizabeth Holland, 1802–1805* (London, 1910), p. 92. See also William E. B. Starkweather, *Paintings and Drawings of Francis Goya* (New York, 1916), pp. 55–56.

9 As reported by Joseph Townsend in *A Journey through Spain in the Years 1786 and 1787 with Particular Attention to the Agriculture, Manufactures, Commerce, Population, Taxes, and Revenue of that Country, and Remarks in Passing through a Part of France*, vol. 2 (London, 1791), pp. 144–45.

10 Feuchtwanger (note 1), pp. 14–15.

11 Angel Canellas López (ed.), *Francisco de Goya: Diplomatario* (Saragossa, 1981), Addenda, p. 35, no. 196.

12 Ibid., p. 272, no. 112.

13 Ezquerra del Bayo (note 2), p. 147.

14 Canellas López (note 11), p. 453, LXVI.

15 Ibid., p. 313, no. 185.

16 Ibid., p. 455, LXIX.

17 Quoted in Janis Tomlinson, *Francisco Goya y Lucientes, 1746–1828* (London, 1994), p. 94.

18 Ezquerra del Bayo (note 2), p. 184.

19 As reported by Mariano Francisco Nipho in his essay "Cajón de sastre literato," 1781; see Carmen Martín Gaite, *Usos amorosos del dieciocho en España* (Madrid, 1972), pp. 105–06.

20 As reported by Juan Semprey Guarinos in his essay "Historia del lujo," 1788; quoted in Martín Gaite (note 19), p. 132.

21 The *Portrait of the Duchess of Alba in White* is now considered the first authenticated portrait of the duchess from Goya's hand.

22 This hypothesis was advanced by Jeannine Baticle in her essay "Goya y la Duquesa de Alba: Que tal?" in Francisco Calvo Serraller and Isabel García de la Rasilla (eds.), *Goya: Nuevas visiones*, Madrid, 1987.

23 A written document of the Real Casa, dated March 31, 1798; quoted in Valentín de Sambricio, *Tapices de Goya* (Madrid, 1946), doc. 188.

24 Feuchtwanger (note 1), p. 258.

25 Joseph Townsend (note 9).

26 The sonnet is by Don Manuel Aria de Arjona; quoted in Ezquerra del Bayo (note 2), pp. 192–93.

27 Canellas López (note 11), p. 463, LXXXIII.

28 Ezquerra del Bayo (note 2), pp. 190–91.

29 Enrique Pardo Canalís, "Una visita a la galería del Príncipe de la Paz," *Goya: Revista de Arte*, 148–50 (1979), pp. 300–11.

30 Canellas López (note 11), p. 491, CXXXV.

31 Martín Gaite (note 19), p. 42.

32 Ibid., p. 43.

33 From the dictionary entry "coqueta," by Torres y Pando, in *Diccionario castellano* (Madrid, 1786–93); quoted in Martín Gaite (note 19), p. 193.

34 Ezquerra del Bayo (note 2), p. 212.

35 Ibid., p. 213.

36 For an interpretation of the composition, see Folke Nordström, *Goya, Saturn and Melancholy: Studies in the Art of Goya* (Stockholm, 1962), pp. 142f.

37 Quoted in Alfonso E. Pérez Sánchez and Julián Gállego, *Goya: The Complete Etchings and Lithographs* (Munich, 1995), p. 32. The following commentaries on the *Caprichos* are quoted in *Goya: Das Zeitalter der Revolutionen, 1789–1830*, exh. cat., Hamburger Kunsthalle, 1980–81, p. 52.

38 Ezquerra del Bayo (note 2), p. 220.

39 Paula de Demerson, *María Francisca de Salas Portocarrero (Condesa del Montijo)* (Madrid, 1975), p. 360.

40 Ibid.

41 Kurt von Nörvich, *La Duquesa de Alba* (Barcelona, 1959), p. 243.

42 Letter published in Ezquerra del Bayo (note 2), pp. 225–26.

43 The autopsy report was published in minute detail by Carlos Blanco Soler, *Esbozo psicológico, enfermedades y muerte de la Duquesa María del Pilar Teresa Cayetana de Alba* (Madrid, 1946).

44 In the prologue to Blanco Soler, Piga Pascual, and Pérez Petinto, *La Duquesa de Alba y su tiempo* (Madrid, 1949).

45 Ezquerra del Bayo (note 2), pp. 212–13.

46 Ibid., p. 213.

47 See the interpretation in Konrad Renger and Gerd Unverfehrt (eds.), *Goya: Radierungen*, exh. cat., Kunstsammlung der Georg-August-Universität Göttingen, 1976, p. 29.

48 Ezquerra del Bayo (note 2), p. 61.

49 Antonio Matilla Tascón, "La herencia de la duquesa de Alba," in: *Hidalguía*, 1979. See also Baticle (note 22), p. 70.

SELECTED BIBLIOGRAPHY

PUBLICATIONS ON MARÍA TERESA CAYETANA DE SILVA, XIIITH DUCHESS OF ALBA

Baticle, Jeannine. "Goya y la Duquesa de Alba: Que tal?" In Francisco Calvo Serraller and Isabel García de la Rasilla (eds.), *Goya: Nuevas visiones*, pp. 61–71. Madrid, 1987.

Blanco Soler, Carlos. *Esbozo psicológico, enfermedades y muerte de la Duquesa María del Pilar Teresa Cayetana de Alba*. Madrid, 1946.

——Blanco Soler, Carlos, Piga Pascual, and Pérez Petinto. *La Duquesa de Alba y su tiempo*. Madrid, 1949.

Bonmatí de Codecido, Francisco. *La Duquesa Cayetana de Alba: Maja e musa de D. Francisco de Goya*. Valladolid, 1940.

Crowe, Ann Glenn. "The Art of Goya and the Duchess of Alba (1792-1802): Minor Themes and Major Variations." Ph.D. diss. Stanford, CA, Stanford University, 1989.

Ezquerra del Bayo, Joaquín. *La Duquesa de Alba y Goya: Estudio biográfico y artístico*. Madrid, 1928. 2nd ed., Madrid, 1959.

Matilla Tascón, Antonio. "La herencia de la duquesa de Alba" in: *Hidalguía* (1979)

Schmidt, Marie-France. *La Duchesse d'Albe: Noble Dame de l'Espagne*. Lausanne, 1967.

PUBLICATIONS ON FRANCISCO DE GOYA Y LUCIENTES

Beruete y Moret, Aureliano de. *Goya*. Madrid, 1928.

Calvo Serraller, Francisco, and Isabel García de la Rasilla (eds.). *Goya: Nuevas visiones*. Madrid, 1987.

Camón Aznar, José. *Francisco de Goya, 1746–1828*. 4 vols. Saragossa, 1980–82.

Canellas López, Angel (ed.). *Francisco de Goya: Diplomatario*. Saragossa, 1981.

Gassier, Pierre. *The Drawings of Goya*. 2 vols. New York and London, 1973, 1975.

Gassier, Pierre, and Juliet Wilson-Bareau. *The Life and Complete Work of Francisco Goya, with a Catalogue Raisonné of the Paintings, Drawings and Engravings*, New York and London, 1971.

Glendinning, Nigel. *Goya and his Critics*. London, 1977.

Goya: Das Zeitalter der Revolutionen, 1789–1830. Exhibition catalogue. Hamburg, Hamburger Kunsthalle, 1980–81.

Goya: El capricho y la invención. Exhibition catalogue. Madrid, Museo del Prado, 1994.

Gudiol, José. *Goya 1746-1828: Biografía, estudio analítico y catálogo de sus pinturas*. 4 vols. Barcelona, 1970. Abridged ed., 2 vols., Barcelona, 1980. The latter trans. as *Goya 1746–1828: Biography, Analytical Study and Catalogue of his Paintings*, Barcelona, 1985.

Harris, Enriqueta, and Duncan Bull. *Goya's Majas: Variations on a Theme*. London, 1990.

Held, Jutta. *Francisco de Goya in Selbstzeugnisseen und Bilddokumenten*. Reinbek, 1980.

Helman, Edith. *Transmundo de Goya*. Madrid, 1963.

Hofmann, Werner. *Goya: Traum, Wahnsinn, Vernunft*. Munich, 1981.

Licht, Fred. *Goya: The Origins of the Modern Temper in Art*. New York and London, 1979.

Loga, Valerian von. *Francisco de Goya*. Berlin, 1903.

Mayer, August L. *Francisco de Goya*. Munich, 1923. Trans. by Robert West as *Francisco de Goya*, London and Toronto, 1924.

Nordström, Folke. *Goya, Saturn and Melancholy: Studies in the Art of Goya*. Stockholm, 1962.

Pérez Sánchez, Alfonso E., and Eleanor Sayre. *Goya and the Spirit of Enlightenment*. Exhibition catalogue. Boston, Museum of Fine Arts, 1989.

Sambricio, Valentín de. *Tapices de Goya*. Madrid, 1946.

Sánchez Cantón, Francisco Javier. *The Life and Works of Goya*. Madrid, 1964.

Tomlinson, Janis. *Goya in the Twilight of Enlightenment*. London, 1992.

———. *Francisco Goya y Lucientes, 1746–1828*. London, 1994.

PHOTO CREDITS

Biblioteca Nacional, Madrid: pp. 56, 57 (top)

British Library, London: p. 29

Musée Goya, Castres, J. C. Ouradou: p. 98 (right)

The Hispanic Society of America, New York: frontispiece, p. 48

Institut Amatller d'Art Hispànic, Barcelona: p. 33, 80

Meadows Museum, Dallas, TX: p. 30

The Metropolitan Museum of Art, New York: pp. 26, 47

Museo del Prado, Madrid: pp. 11, 16, 17, 19, 39, 41, 44, 54–55, 58–59, 64, 70, 76, 78, 94, 96, 97, 99 (top), 102 (bottom)

Museo provincial de Bellas Artes, Valencia: p. 20

The National Gallery of Art, Washington, D.C.: p. 100

Elke Walford, Hamburg: p. 61

DATE DUE